THE LONDON, MIDLAND AND SCOTTISH RAILWAY

SCOTTISH RAILWAY

—— VOLUME SEVEN ——

FROM ST PANCRAS TO SHEFFIELD

Stanley C. Jenkins and Martin Loader

AMBERLEY

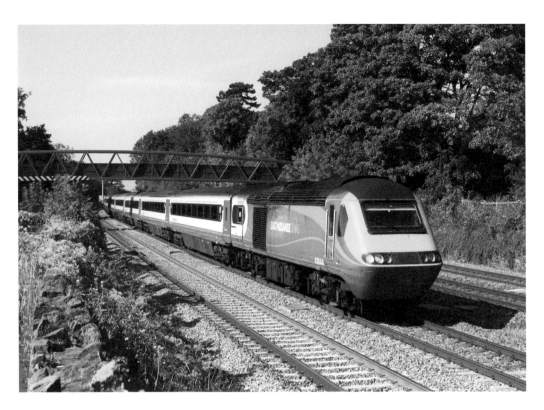

Barrow-upon-Soar

HST power car No. 43044 passes Barrow-upon-Soar while working the 13:28 Nottingham to St Pancras International service on 15 September 2012.

First published 2020

Amberley Publishing
The Hill, Stroud, Gloucestershire, GL5 4EP
www.amberley-books.com

Copyright © Stanley C. Jenkins and Martin Loader, 2020

The right of Stanley C. Jenkins and Martin Loader to be identified as the Authors of this work has been asserted in accordance with the Copyrights, Designs and Patents Act 1988.

ISBN 978 1 4456 9822 9 (print)
ISBN 978 1 4456 9823 6 (ebook)

British Library Cataloguing in Publication Data.
A catalogue record for this book is available from the British Library.

Typesetting by Aura Technology and Software Services, India. Printed in Great Britain.

ACKNOWLEDGEMENTS

The photographs used in this publication were obtained from the Lens of Sutton Collection, and from the authors' own collections.

A NOTE ON CLOSURE DATES

British Railways closure announcements referred to the first day upon which services would no longer run, which would normally have been a Monday. However, the final day of operation would usually have been the preceding Sunday (or, if there was no Sunday service, the preceding Saturday). In other words, closure would take place on a Saturday or Sunday, whereas the 'official' closure would become effective with effect from the following Monday.

HISTORICAL INTRODUCTION

The Midland main line from London St Pancras to the north of England is one of Britain's most important trunk routes. With its various loops and connecting lines, this major artery of communication links major centres of population such as Leicester, Derby, Nottingham, Sheffield, Manchester and Leeds. Notwithstanding its obvious importance as a busy main line, the Midland route was built in a piecemeal fashion, the various sections (from London northwards) being the Midland Railway London Extension (opened 1868), the Leicester & Hitchin Railway (1857), the Midland Counties Railway (1840), the North Midland Railway (1840) and the Sheffield & Chesterfield Railway (1870).

In recent years the Midland line has been regarded primarily as a link between London and Sheffield, although a number of services have continued to run through to Leeds, Manchester and other destinations in the north of England. However, during the Midland Railway period the best trains had run northwards beyond Leeds, and thence along the spectacular Settle and Carlisle route which, in turn, provided a direct line to Scotland, via the Glasgow & South Western Railway. Prestigious Anglo-Scottish trains no longer run on the Midland main line, but this historic route remains in operation as a vital part of the national railway system.

THE MIDLAND COUNTIES RAILWAY

A line between London, Leicester and Derby had been suggested as far back as the 1820s, and in modified form this important project was taken up by the promoters of 'The Midland Counties Railway'. With Charles Blacker Vignoles (1793–1874) as its engineer, the necessary Bill was sent up to Parliament for the 1836 session, and in spite of initial opposition from the promoters of the North Midland Railway, and other opponents, the Midland Counties scheme received the Royal Assent on 21 June 1836.

The authorised route commenced at Derby by a junction with the North Midland Railway, while at its southern end the Midland Counties Railway would form a junction with the London & Birmingham Railway to the west of Rugby station. Although Rugby was not in itself an important centre for originating traffic, it was, at that time, a major strategic destination, and it was envisaged that Midland Counties trains would run southwards to London via the London & Birmingham Railway, which would, in turn, provide a through route for MCR traffic to and from the Metropolis.

Construction was soon under way, and the first section of the Midland Counties Railway was officially opened between Derby and Nottingham on 29 May 1839 when *Sunbeam* – a four-wheeled locomotive built by Messrs Jones, Turner and Evans – hauled a six-coach train over the new line in a time of 44 minutes; public services commenced a week later, on 4 June 1839. The line was ceremonially opened as far as Leicester on 4 May 1840, the occasion being marked in appropriate

fashion by the running of a directors' special. However, the main celebrations took place on Tuesday 5 May 1840, when the MCR was opened for public traffic between Trent Junction, Loughborough and Leicester.

As usual in those days, the opening day was treated as a great public holiday and, despite a spell of decidedly unpropitious weather, many thousands of spectators turned out to welcome the first trains. The first northbound working left Leicester at 7.30 a.m. with about fifty first-day travellers aboard, and on arrival at Loughborough, about half an hour later, it was welcomed enthusiastically by vast crowds of cheering spectators who thronged the bridges and embankments. Two months later, on 29 June 1840, the MCR was officially completed throughout to a temporary station at Rugby. Public services commenced on the following day, and through services were soon running to Leeds via Normanton and the North Midland Railway.

THE NORTH MIDLAND RAILWAY

The North Midland Railway was a few days younger than the Midland Counties Railway, having been incorporated by Act of Parliament on 4 July 1836, with powers for the construction of a railway from Derby to Leeds via Chesterfield, Masborough and Normanton – a distance of 72 miles. The line, which was engineered by George and Robert Stephenson, involved some major feats of civil engineering, including 9,500,000 cubic yards of earthwork, 200 bridges and seven tunnels – the latter having a total length of 2¼ miles.

The first section of the line was opened between Derby and Masborough, a distance of 40 miles, on 11 May 1840, and the route was completed throughout to Leeds on 30 June. At Masborough, the line formed a junction with the Sheffield & Rotherham Railway, which had been opened on 31 October 1838, while further junctions at Normanton provided connections with the York & North Midland Railway and the Manchester & Leeds line. An early timetable, issued in 1842, claimed that the station houses were of 'unequalled architectural beauty' – the North Midland Railway being notable for the superior quality of its architecture.

The obvious success of early lines such as the Midland Counties and North Midland railways encouraged the promotion of further schemes throughout the British Isles and, by the mid-1840s, a railway mania gripped the land. By 1846 the bones of the present-day railway system had been firmly laid, and the familiar pattern of railway politics and geography had been firmly established – the Midland Railway having been formed in 1844 by the amalgamation of the Midland Counties, the North Midland and the Birmingham & Derby Junction companies, while just two years later the rival London & North Western Railway was formed by a similar amalgamation between the London & Birmingham and Grand Junction railways.

THE LEICESTER & HITCHIN RAILWAY

The newly created Midland and London & North Western companies were soon in dispute at Rugby, and it became abundantly clear that the arrangements

whereby Midland trains would reach London over North Western tracks were wholly unsatisfactory. The Midland therefore concluded an alternative working agreement with the Great Northern Railway, which would allow MR services to run to and from the GNR station at King's Cross. To facilitate this change of plan, the MR sought Parliamentary consent for a line from Wigston, near Leicester, to Hitchin, on the Great Northern Railway.

The proposed line was, in effect, a revival of an earlier project known as the South Midland Railway, which would have diverged from the Midland system at Wigston and run southwards to Market Harborough and Bedford. This scheme was taken up by the Midland, and in 1847 the company obtained Parliamentary consent for a 62¼-mile main line between Wigston, Bedford and Hitchin. However, the powers were allowed to lapse, and it was necessary for a further Bill to be sent up to Parliament for the 1853 session.

Accordingly, in November 1852, the Midland Railway Company gave formal notice that an application would be made to Parliament for powers to construct a railway 'with all proper works and conveniences connected therewith', commencing by a junction with the line of the Midland Railway near Leicester 'at a point thereon, situate four furlongs or thereabouts to the north of the Wigston Station of the said railway, and in the parish of Wigston Magna, otherwise Great Wigston, in the County of Leicester', and 'terminating by a junction with the line of the Great Northern Railway at or near the Hitchin station of that railway in the Parish of Hitchin in the County of Hertford'.

The revived Leicester and Hitchin scheme received the Royal Assent on 4 August 1853, and the Midland was thereby empowered to construct a railway running south-east and thence southwards via Market Harborough, Kettering, Wellingborough and Bedford to Hitchin. The authorised route presented many engineering difficulties, in that it crossed an area of rolling Cotswold-type countryside, which necessitated some major earthworks. There were, moreover, problems at Bedford, where there was controversy concerning the position of the Midland station. Construction was, nevertheless, soon under way, the main contractor being Thomas Brassey (1805–77).

The Leicester & Hitchin Railway was opened for goods traffic throughout its length between Wigston and Hitchin on 15 April 1857. The line was ceremonially opened for local passenger traffic on 7 May, and regular services commenced on the following day. Through Midland services to King's Cross, via Hitchin and the GNR, commenced on 1 February 1858 under an arrangement whereby the Midland undertook to pay tolls to the GNR of not less than £20,000 per annum. There was, at first, no Midland station at Bedford and, for the first few months of operation, Midland services used the London & North Western station at Bedford St Johns.

THE MIDLAND EXTENSION TO LONDON

The new route did not reach London, but its opening seemed to herald the dawn of a new age for the Midland Railway. The Midland Chairman John Ellis (1789–

1862), who had been associated with the MR and its constituents from their inception, claimed that the building of the Leicester to Hitchin line was the 'wisest piece of policy that the company had ever pursued', as it freed the railway from dependence upon the L&NWR.

Unfortunately, this new route to London was little better than the original route via Rugby and the L&NWR. It soon became clear that, as a result of continued traffic growth on both lines, there was insufficient capacity for Midland and GNR traffic between Hitchin and King's Cross, and this led to inevitable friction between the Midland and Great Northern companies. The Hitchin line was therefore replaced by the Midland's London extension between Bedford and St Pancras, which was sanctioned by Parliament on 22 June 1863.

Contracts for the construction of this 50-mile main line were let to two firms, Messrs Brassey and Ballard being responsible for the 35-mile section between Bedford and Radlett, while Joseph Firbank secured the contract for construction of the remaining 15 miles between Radlett and St Pancras. The new main line was virtually complete by the summer of 1867, and goods trains began running between Bedford and London in September 1867.

Work continued unabated throughout the next few months, and although the palatial London terminus at St Pancras was still under construction, passenger services began running between Bedford and London (Moorgate Street) on Monday 13 July 1868. On 18 July *The Leicester Chronicle* reported that 'several gentlemen' had gone down to the station on the first day of operation 'for the purpose of inspecting the new line, and all were charmed with the condition of the road, over which the train ran as smoothly as it might be supposed to do over a billiard table'. A 'perfect system' of signalling had been adopted, while the 'stations attracted great attention on account of the completeness of their arrangements', with 'lavatories and waiting rooms of the most improved description', and 'splendid platforms, immensely long, and roofed over with iron and glass, supported by slender iron pillars'.

Long distance Midland express services continued to use the GNR terminus at King's Cross until the new main line was opened throughout for passenger traffic on 1 September 1868 – the first train to enter the new terminus at St Pancras being the up mail from Leeds, which arrived at 4.15 a.m. As a result of these complex developments, the Midland main line came into being as a through route to London, and the Midland Railway was able to take its rightful place as one of Britain's greatest railway companies. The superseded stretches of line from Leicester to Rugby and between Bedford and Hitchin were relegated to branch line status, but the major section of the 1857 Leicester & Hitchin line between Wigston North Junction and Bedford formed an integral part of the new trunk route between London, the Midlands and the North of England.

SUBSEQUENT DEVELOPMENTS

Meanwhile, at the northern end of the route, the Sheffield & Chesterfield Railway had been authorised in 1864 as a direct link to Sheffield, which would obviate

the lengthy detour via Rotherham that had hitherto been necessary. This new line was opened on Monday 2 February 1870, with intermediate stations at Unstone, Dronfield, Millhouses & Eckershall, Abbey Houses and Heeley. A further stopping place was opened at Sheepbridge on 1 August 1870, while Dore & Totley station was brought into use on 1 February 1872.

In the next few years the Midland main line went from strength to strength, and as a result of growing passenger and freight traffic the route was progressively improved. Much of the line was converted from double to multiple track, with convenient separation of main line and goods traffic. In this context, it should be mentioned that the primary traffic flows on the Midland main line were coal and passengers, and by the end of the Victorian period the MR company was carrying 45 million passengers and 34 million tonnes of freight per annum.

Further developments took place during the 1870s, when the Midland constructed additional lines from Melton Mowbray to Nottingham and from Glendon South Junction to Manton, these new lines being opened on 2 February 1880 and 1 March 1880 respectively. An alternative line was thereby brought into use between Kettering, Melton Mowbray and Nottingham. The 'Nottingham Direct Line' was particularly useful, insofar as it provided much-needed extra capacity on the busy Midland route.

In 1923 the Midland Railway became part of the London Midland & Scottish Railway (LMS) under the provisions of the Railways Act 1921, while on 1 January 1948 the railways were taken into state ownership by the post-war Labour government. However, as far as ordinary travellers were concerned, these momentous changes of ownership had little immediate effect, and the Midland main line continued to operate as a major trunk route linking London, Sheffield and the north of England.

The years immediately following the Second World War were a time of rigid austerity in which petrol and other commodities were strictly rationed, and this ensured that the railway system remained busy. Moreover, the post-war Labour government was openly pro-rail in its transport policies, and this factor seemed to guarantee that the railways would have a secure future as part of a fully co-ordinated transport system. In 1951, however, an incoming Conservative government initiated a reversal of policy, and the recently nationalised railways were soon being portrayed as obsolete relics of the Industrial Revolution that would have to be replaced by road transport whenever and wherever possible.

This hostile attitude resulted in widespread closures, two of the first casualties being the Bedford to Hitchin line and the Bedford to Northampton branch, which lost their passenger services with effect from 1 January 1962 and 5 March 1962 respectively.

Outright government hostility towards the nationalised railways reached its peak in 1963 with the publication of the Beeching Report, which recommended the closure of 2,363 stations and the withdrawal of passenger services from one third of the BR network. As far as Midland main line was concerned, the Beeching proposals appeared to be fairly innocuous, although the Midland

main line would lose its local passenger services between Nottingham, Derby, Leicester London Road and Kettering.

Although St Pancras had not been listed for closure in the Beeching Report, the station was threatened with closure and rationalisation during the 1960s and 1970s. One of the suggestions put forward at that time would have involved the transfer of Midland main line services to Euston, while suburban and semi-fast services would have been diverted into Moorgate (Metropolitan) station via King's Cross and the Widened Lines. In 1967 it was reported that the cost of the proposed rationalisation scheme would be around £8.5 million.

On a more positive note, it was subsequently decided that the southern end of the Midland main line would be electrified on the 25 kV AC overhead system between Moorgate and Bedford. Construction began in 1976, and the overhead catenary was switched on between Bedford and Luton Hoo on 1 January 1981, so that drivers could be trained. Unfortunately, the scheme was delayed by a dispute with ASLEF, the train drivers' union, over single manning, but when this problem was finally resolved BR was able to introduce a new service on 11 July 1983, using newly built Class 317 electric multiple units. At the time of writing, electrification is being extended northwards from Bedford to Kettering as part of an upgrade scheme for the Midland main line.

Meanwhile, at the southern extremity of the route, the fortunes of St Pancras station have been utterly transformed by the construction of the Channel Tunnel Rail Link (CTRL), which was formally opened between Dolland Moor and Fawkham Junction on 16 September 2003 and completed throughout to St Pancras on 6 November 2007, when the enlarged station was officially opened by HM Queen Elizabeth II. St Pancras International was opened for business at 9:00 a.m. on 14 November 2007, the first public service being the 11:06 to Brussels. The Fawkham Junction to St Pancras section is heavily engineered with much of the route being in tunnels, while there are also crossings of the Thames, the East Coast Main Line and the London Orbital motorway. Major works were also required at St Pancras, where a new roof extension was constructed immediately to the north of the Victorian train shed.

SOME NOTES ON MOTIVE POWER

At the end of the Victorian period the fastest trains on the Midland main line were hauled by elegant Johnson 4-2-2 singles, though these were subsequently replaced by 4-4-0 tender engines, such as the famous Class 3 4-4-0s and Class 4 Midland Compounds. Freight duties were undertaken by a corresponding range of 0-6-0 goods engines, including the ubiquitous Class 2, Class 3 and Class 4 locomotives. None of these engines were really large, and it was often necessary for heavy passenger or freight workings to be double-headed. On many occasions, elderly 2-4-0s or other types could be seen piloting 4-4-0s on express services, while heavy coal workings were often hauled by two 0-6-0s in tandem.

At the end of the nineteenth century the Midland main line was served by six Up and six Down London to Manchester services, together with a number of

Anglo-Scottish expresses to and from Glasgow or Edinburgh, and other trains to Sheffield or Bradford. The best trains were probably the 10.30 a.m. express from St Pancras to Glasgow and the 2.00 p.m. service from St Pancras to Manchester Central, which reached Leicester in 115 and 112 minutes respectively. These services were lightly loaded – the standard load for a Class 4 Midland 4-4-0 being no more than 240 tonnes, while Class 2 locomotives could manage only 180 tonnes.

The Midland Railway remained stubbornly committed to a 'small engine' policy, the assumption being that four-coupled locomotives could handle all passenger services on inter-city routes, with fast light trains being run at frequent intervals. This idea was initially adopted by the LMS after the 1923 Grouping, but in due course other ideas prevailed, and the company was obliged to introduce larger engines to obviate double-heading on many of its best trains. In furtherance of this aim, William Stanier was recruited from the GWR and the new Chief Mechanical Engineer soon introduced a range of standard locomotives which were, in effect, LMS versions of the familiar GWR engine designs.

In 1934, for instance, Stanier introduced his two-cylinder Black Five 4-6-0s, which were clearly inspired by the highly successful GWR Hall Class. These excellent new locomotives soon appeared on the Midland main line, together with the visually similar Jubilee Class 4-6-0s, which carried LMS red livery from their inception and were therefore known in some quarters as the Red Ones to distinguish them from the Black Fives. The Jubilees were a three-cylinder design with 6-foot 9-inch coupled wheels. After early teething troubles they settled down to their work on the Midland main line, and in this capacity many enthusiasts consider that they became star performers on a route that had not hitherto been noted for outstanding locomotive work.

Other LMS classes seen on the Midland route at various times included the former L&NWR Claughtons (which were said to have been indifferent performers), together with Patriot Class 4-6-0s and Royal Scot 4-6-0s, the Royal Scots being the largest 4-6-0s employed on the Midland route, with a power classification of 7P. The largest passenger engines seen on the route in BR days were the BR 4-6-2s, some typical examples being Nos 70014 *Iron Duke*, 70021 *Morning Star* and 70032 *Tennyson*. In later years, local passenger and freight services were worked by the usual range of LMS classes, including Class 8F 2-8-0s, Class 4F 0-6-0s, Class 3F 0-6-0s, Class 4P compound 4-4-0s, Class 3MT 2-6-2Ts and Class 3F 0-6-0T shunting locomotives.

Main line diesels, in the form of the curious English Electric Type 2 Co-Bos, were introduced in 1958–59, but the most characteristic diesel locomotives seen on the Midland route during the British Railways period were the massively constructed Class 45 1Co-Co1s, which hauled the most important workings until the advent of the HSTs. The HSTs, along with Class 222 Meridian diesel multiple units, provide all passenger services at the time of writing, although route electrification (initially only to Kettering and Corby) is now under way, and will shortly bring a change of rolling stock to the route.

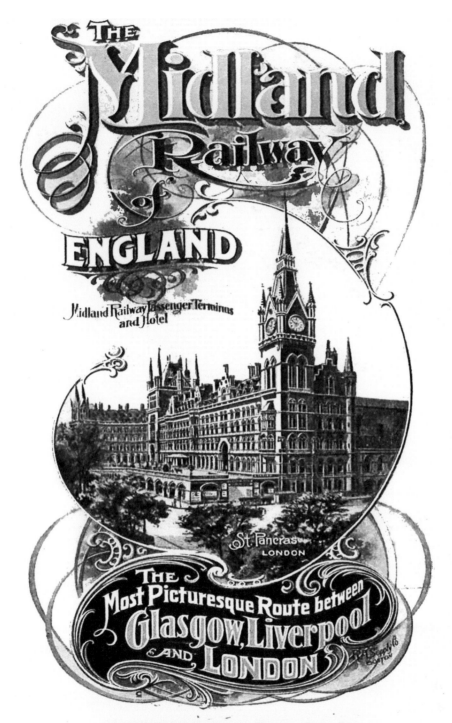

The cover of a Midland Railway timetable, showing St Pancras station and hotel.

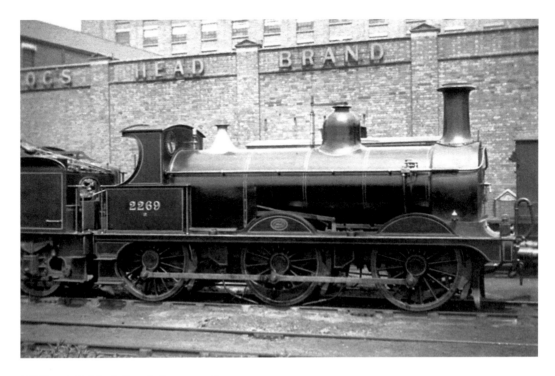

Midland & LMS Goods Locomotives

Above: Midland Railway Class 2F 0-6-0 No. 2269, a typical small-boilered freight locomotive. *Below*: A works photograph of Class 4F 0-6-0 No. 3835, a type of engine which was introduced in 1911 to a design by Sir Henry Fowler. These locomotives were a direct development of the earlier Midland six-coupled designs, and they were adopted as a standard type during the LMS period. No less than 572 examples were built between 1924 and 1941, in addition to 197 engines of this same basic type that had been built by the Midland Railway prior to the Grouping, and five more that had been constructed for service on the Somerset & Dorset Joint Railway.

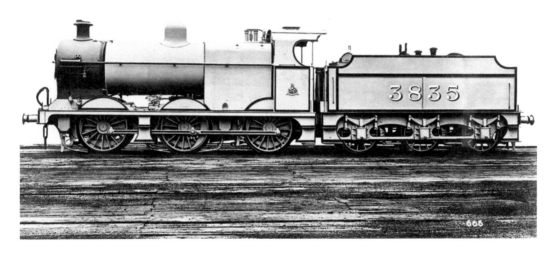

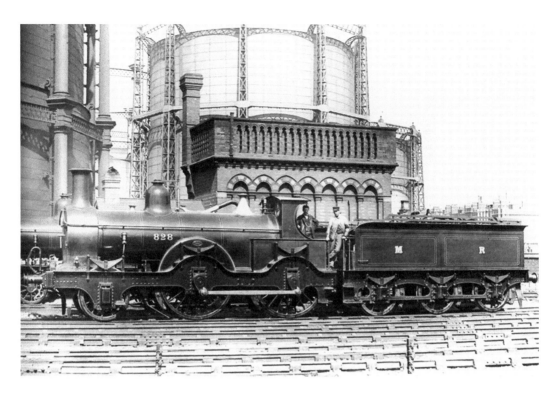

Passenger & Mixed Traffic Locomotives

Above: Midland 2-4-0 locomotive No. 828 poses for the camera alongside Kensal Green Gas Works, which was sited immediately to the north of St Pancras station. *Below*: Class 5MT 4-6-0 No. 5167. These mixed traffic locomotives – popularly known as the 'Black Fives' – were designed by Sir William Stanier (1876–1977) and introduced in 1934. They were among the most successful steam locomotives ever built, and no less than 842 examples were constructed.

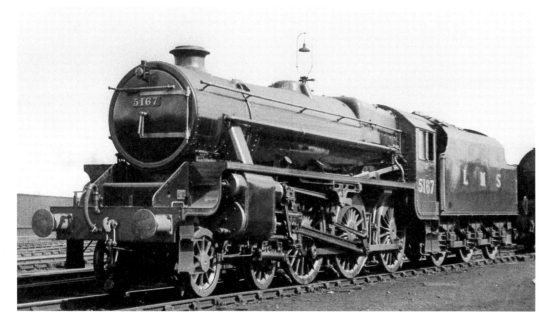

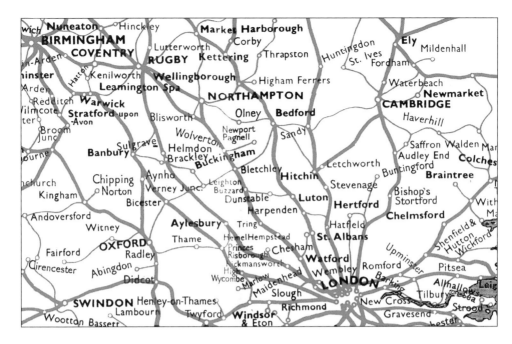

This official British Railways map, dating from 1958, shows the various main line routes that extend northwards from London. The Midland main line can be seen in the centre of the map, running north-west via St Albans, Harpenden, Luton, Bedford, Wellingborough and Market Harborough.

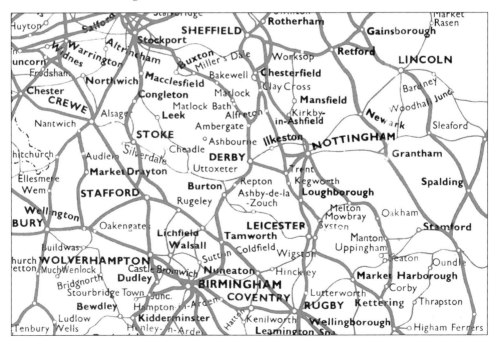

The northern section of the Midland route extends north-west via Leicester, Loughborough, Derby and Chesterfield to Sheffield.

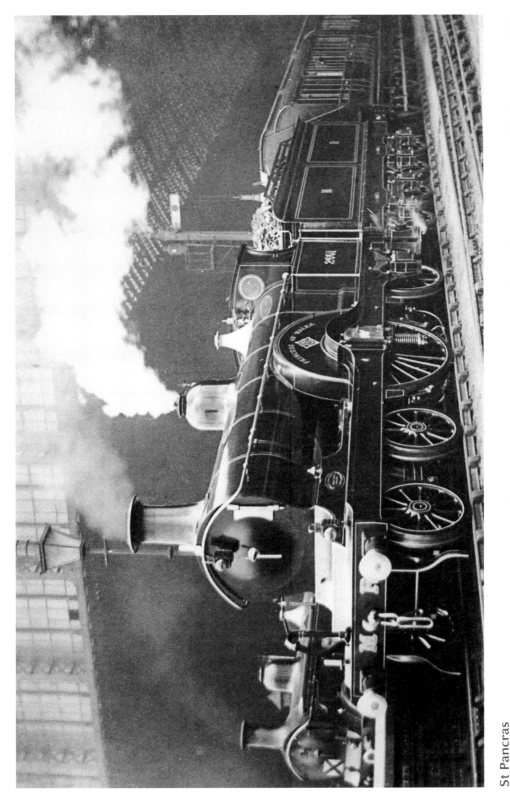

St Pancras

Johnson 4-2-2 single-wheeler No. 2601 *Princess of Wales* departs from St Pancras station during the Midland Railway period. This locomotive, which was built in 1900, was awarded the Grand Prix at the Paris Exhibition held in that year.

15

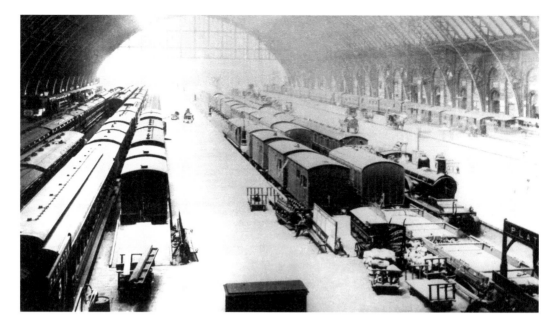

St Pancras

When opened on 1 October 1868, St Pancras station had consisted of five terminal platforms beneath a gigantic overall roof, the two westernmost platforms being the departure side, while the three platforms on the eastern side were regarded as the arrival side. There were a number of carriage sidings between the arrival and departure platforms, together with a spacious cab approach road. These arrangements were altered around 1892 when two additional platforms were brought into use on the site of the carriage sidings. The platforms were numbered in sequence from 1 to 7 – Platform 1 being on the west side while Platform 7 was sited on the eastern side of the station. The accompanying pictures show the interior of the station around 1912 (above) and *c.* 1971 (below).

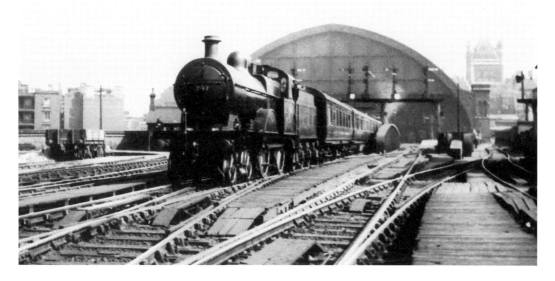

St Pancras

Above: Johnson Class 3 4-4-0 No. 747 departs from St Pancras during the LMS era. *Below*: A double-headed express is pictured at St Pancras during the early years of the twentieth century, the leading engine being Johnson Class 2 4-4-0 No. 484. The impressive train shed that can be seen in these photographs was designed by William Henry Barlow (1812–1902), who decided that the best solution would be a single-span roof with a width of 240 feet, the widest then in existence. The train shed was 100 feet high and 690 feet in length, and it covered an area of 165,000 square feet. The platforms are situated about 17 feet above local ground level, and this provided room for extensive vaults or cellars, which were used to accommodate Burton-on-Trent beer traffic.

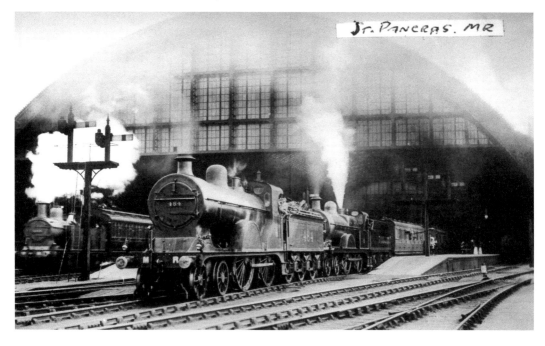

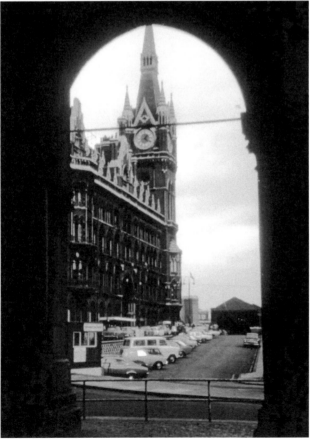

St Pancras – The Midland Hotel

Designed by Sir George Gilbert Scott (1810–77), the Midland Grand Hotel was conceived as an integral part of the great terminus, although financial considerations meant that it was not opened until 5 May 1873, while the curved extension at the west end was not completed until 1876. This monumental structure is constructed of red Nottingham bricks with Ancaster stone dressings and steeply pitched slate-covered roofs. The main façade is of four main storeys with two additional attic storeys lit by gabled dormers. The station is entered via two vehicle arches flanked by pedestrian arches, and the building boasts two impressive towers, the gate tower being 250 feet high, while the soaring clock tower at the south-eastern corner of the building is 270 feet in height. The hotel is now known as the St Pancras Renaissance Hotel.

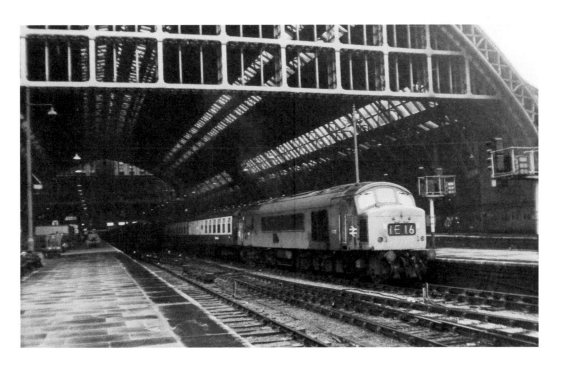

St Pancras

The upper view, which dates from around 1968, shows Peak Class diesel locomotive No. D43, while the lower view depicts a Derby-built Class 127 diesel multiple unit lurking beneath the cavernous train shed. On a minor point of interest, it may be worth mentioning that St Pancras station derives its name from the Parish of St Pancras, in which it is situated. It is generally assumed that St Pancras was a Roman martyr from Phrygia, who was put to death around 304 AD and was buried beneath the Aurelian Way.

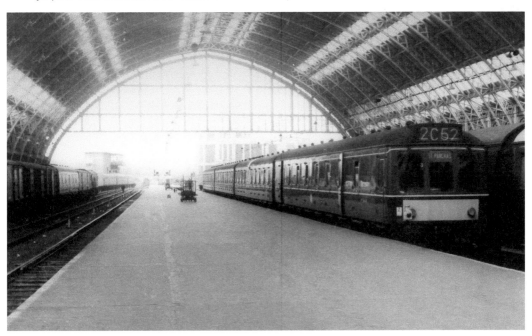

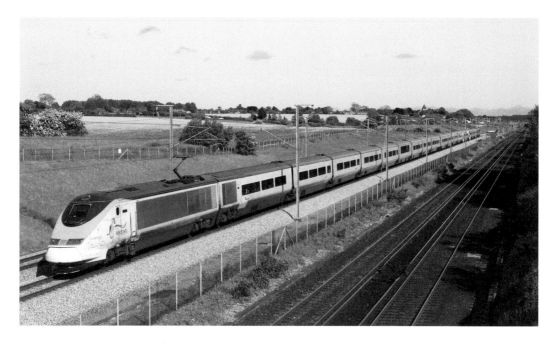

St Pancras International

Above: As mentioned earlier, St Pancras International has been used by Eurostar services since 2007, and in its present form the station has fifteen platforms. A notable feature of the rebuilt terminus is the way in which the extensive cellars have been opened out to provide a bright and cheerful shopping mall. The Channel Tunnel route diverges from the Midland line a short distance to the north of St Pancras station. The accompanying photograph shows Eurostar set No. 3002 heading the 16:56 Brussels to St Pancras International service along the CTRL on 3 June 2013.

Below: A selection of British Railways tickets from the St Pancras suburban area, including eight Edmondson card travel tickets and one paper platform ticket.

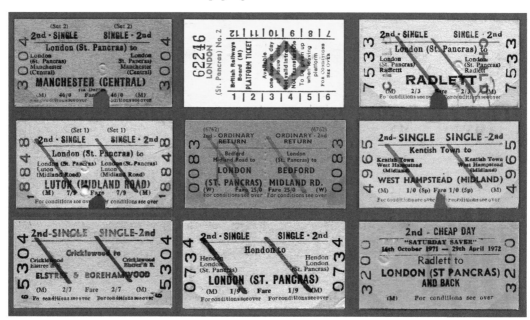

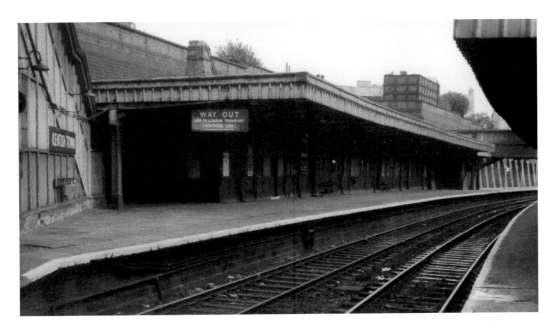

Kentish Town

On leaving St Pancras, the Midland line initially heads northwards, but the direction of travel then turns north-west as trains run through a heavily built up urban area. There are several suburban stations on this section, including Kentish Town (1½ miles), which was opened with the line on 13 July 1868. This busy station has four surface platforms and two underground platforms – the Northern Line having been opened by the London Electric Railway on 22 June 1907. Neighbouring stations at Camden Road and Haverstock Hill were closed in 1916, but Kentish Town has remained in operation, and it now generates around 11 million passenger journeys per annum, including over 8 million Underground passengers.

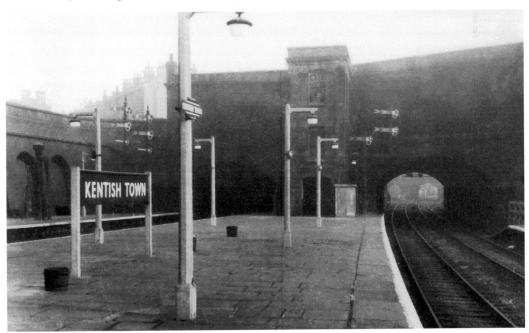

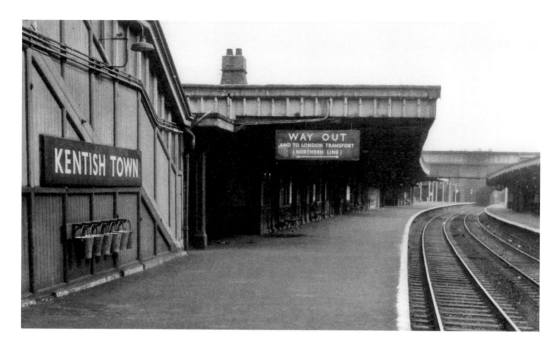

Kentish Town

Above: A general view of Kentish Town station during the British Railways period. *Below*: A Class 127 diesel multiple unit is pictured at Kentish Town, probably around 1964. Built by BR at Derby, these four-car suburban units were introduced in 1959, and they enjoyed a long association with the Midland route. Thirty Class 127 units were built, and each set could accommodate 352 second class passengers (later reduced to 348). They rarely ventured far from the St Pancras to Bedford line, and this earned them the nick-name 'Bed-Pan Units'.

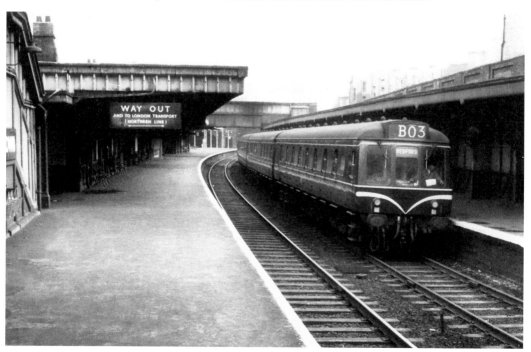

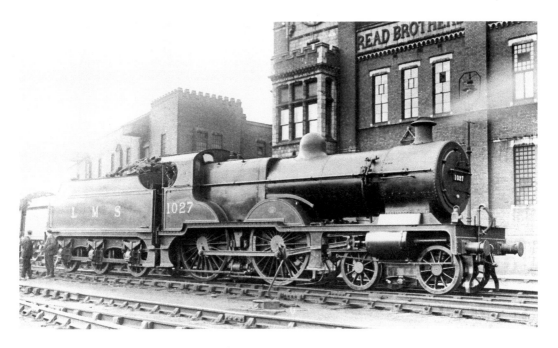

Kentish Town – The Engine Sheds

For railway enthusiasts, Kentish Town was a place of particular interest, in that it was the site of a large motive power depot, the engine sheds being sited immediately to the north of the passenger station on the Up side. The depot was coded 14B during the BR era, and it had an allocation of over 100 locomotives during the 1950s, approximately one third of these being large tender locomotives of the Black Five, Jubilee and Royal Scot classes. There were also large numbers of 2-6-2T or 2-6-4T passenger tank locomotives, together with the usual 3F 0-6-0Ts, Class 4F 0-6-0s and Class 4P 4-4-0s. The upper picture shows Class 4P Compound 4-4-0 No. 1027, while the lower view shows Patriot Class 4-6-0 No. 6000. Both photographs were taken at Kentish Town during the LMS period. The shed was coded 14B from 1948 until its closure in 1963.

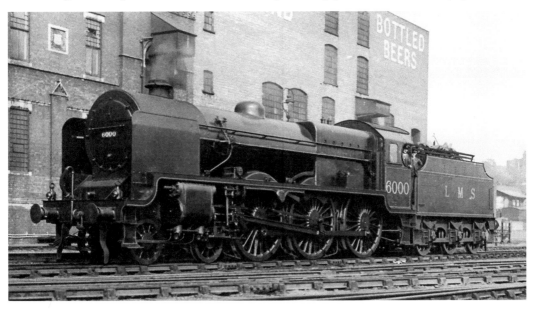

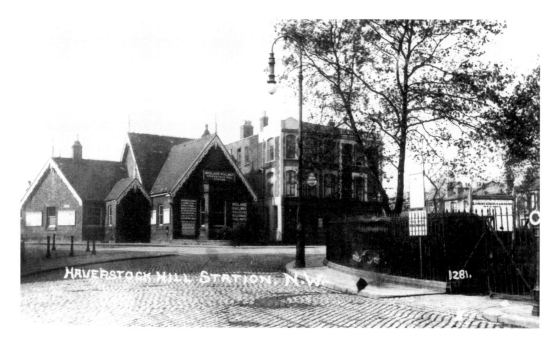

Two Long-Closed Suburban Stations

As mentioned above, there were two long-defunct stations on this part of the route – Camden Road having been sited to the east of Kentish Town station, while Haverstock Hill was situated a short distance to the west. They were opened with the line on 13 July 1868 and closed in January 1916. Both stations were situated in cuttings with their main station buildings at street level. The upper view shows Haverstock Hill station during the Edwardian era, while the lower view provides a glimpse of Camden Road station building during the same period. The latter structure became a garage after closure and, as such, it remained in situ for many years.

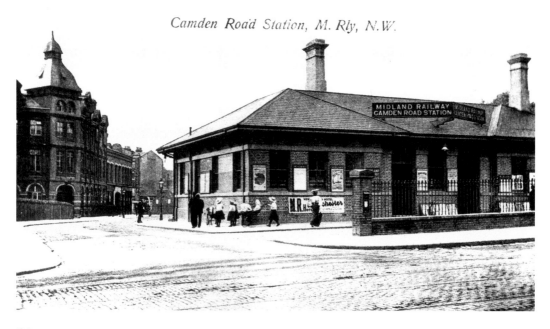

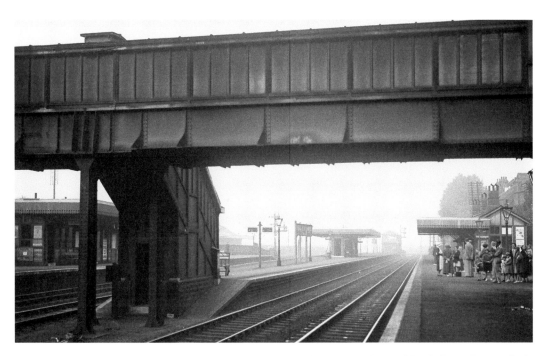

West Hampstead Midland

From Kentish Town trains head westwards through Belsize Tunnel before reaching the next station at West Hampstead Midland, some 4 miles from St Pancras. The original tunnel is 1 mile 62 yards in length, but a second bore, opened in February 1884, has a length of 1 mile 73 yards. West Hampstead was opened as West End on 1 March 1871 and renamed 'West Hampstead & Brondesbury' in 1904. Another change of nomenclature took place in 1905, when the station became 'West Hampstead', while in 1950 the name 'West Hampstead Midland' was adopted. The station is now known as 'West Hampstead Thameslink'.

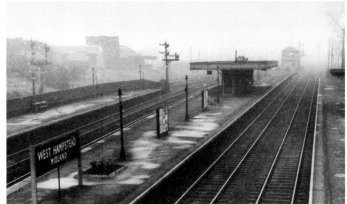

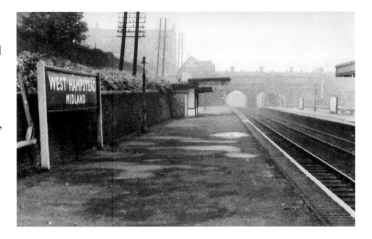

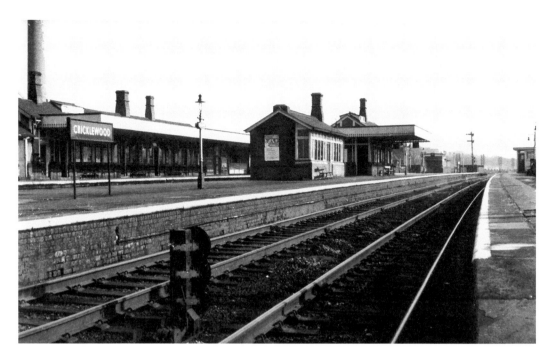

Cricklewood

Curving onto a north-westerly heading, trains descend towards Cricklewood (5¼ miles). Prior to rationalisation, Cricklewood had been a typical Midland Railway suburban station with four platforms and extensive buildings, but its infrastructure has now been modernised. The main station building is situated on the Up side and the platforms are linked by an underline subway. In 1882 Cricklewood became the site of a motive power depot, this facility being sited to the north of the station on the Up side. The depot was coded 14A during the early British Railways period, but the coding was changed to 14B in 1963. The site remains in use as a traction maintenance depot, with extensive stabling and servicing facilities for present-day trains.

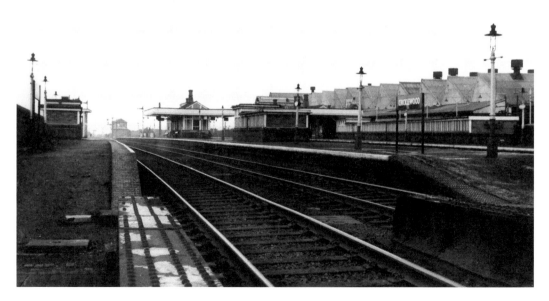

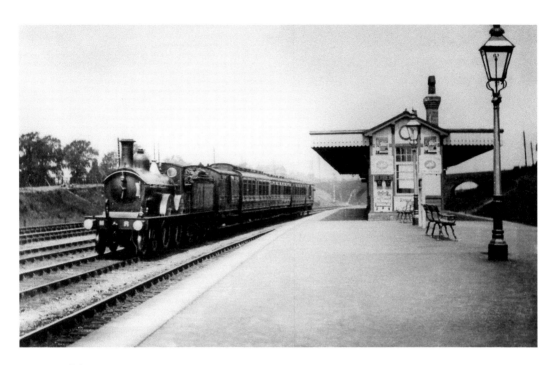

Welsh Harp

Continuing north-west, the route skirts the south-western end of the Welsh Harp Lake, also known as the Brent Reservoir, which developed as a popular resort for Londoners during the Victorian period. A stopping place was opened here on 2 May 1870, but its life was relatively short, and the station was closed in July 1903. The accompanying photographs depict Midland trains passing Welsh Harp during the early 1900s, the train in the upper view being hauled by a Johnson 4-4-0, while the lower view shows a Johnson 4-2-2 single-wheeler.

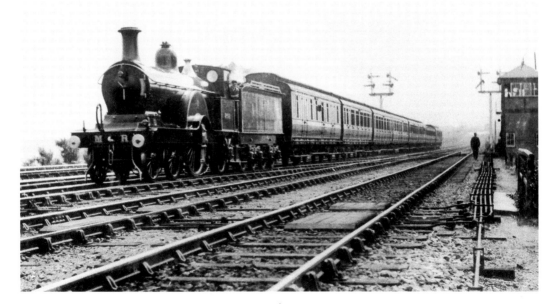

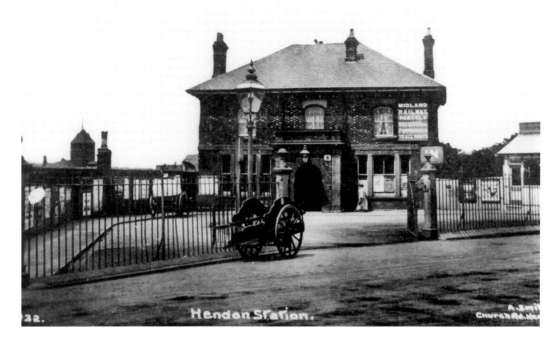

Hendon

Hendon, the next station (7 miles), is less than half-a-mile further on. Opened with the line on 13 July 1868, this four-platform stopping place was another archetypal Midland suburban station with extensive brick buildings, but the original Victorian infrastructure has now been swept away, the present facilities being entirely modern. The station typically handles over 1 million passengers per annum. In 2017–18, for example, the station generated 1.190 passenger journeys. In pre-war days Hendon Aerodrome became well-known as a venue for popular air displays, and although the famous aerodrome has been closed, the RAF Museum has been established on part of the site.

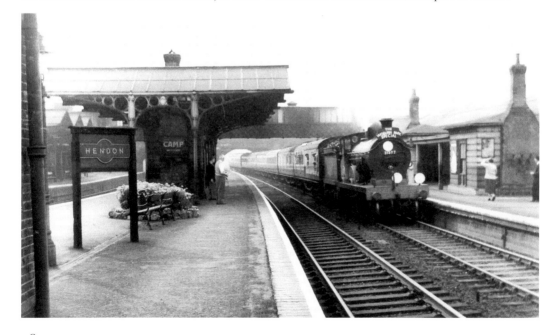

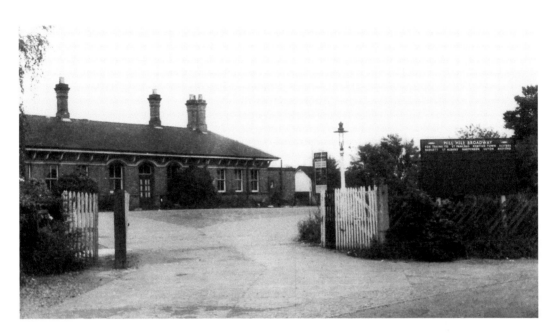

Mill Hill Broadway

With the M1 motorway running parallel on the right-hand side of the line, trains continue to Mill Hill Broadway (9½ miles), which was opened as Mill Hill on 13 July 1868, the name Mill Hill Broadway being adopted in 1950. Like other stations on this section of the line, Mill Hill is a four-platform stopping place, additional platforms having been installed when the line was widened. The illustrations show the station during the heyday of steam operation – the upper view being a glimpse of the station approach, while the lower view shows the platforms. Mill Hill station was extensively rebuilt in connection with motorway construction works, the present-day facilities being largely modern.

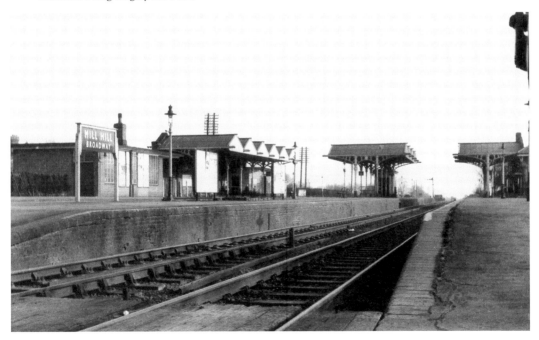

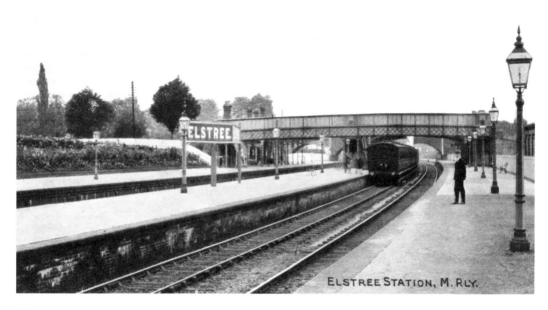

ELSTREE STATION, M. RLY.

Elstree & Borehamwood

Having curved onto a north-westerly heading, the line climbs through the sprawling outer London suburbs to Elstree & Borehamwood (12½ miles). The station is preceded by Elstree Tunnel (1,058 yards), while the rising gradients on this section are mostly at 1 in 160 to 1 in 176. The upper picture, taken from an Edwardian colour-tinted postcard, dates from around 1906, while the lower view shows a 2-6-0 + 0-6-2T Beyer-Garrett locomotive passing through the station at the head of a lengthy coal train – a reminder of the immense amount of coal traffic that was once handled by the Midland Railway.

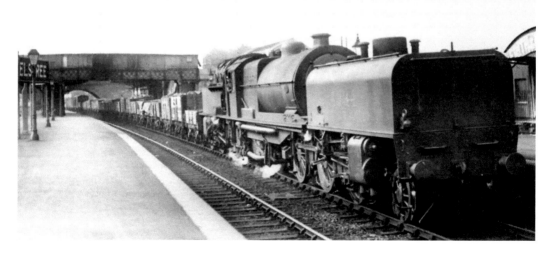

Radlett

From Elstree, the multiple-tracked route descends north-west to the next station at Radlett (15¼ miles). Opened on 13 July 1868, this four-platform suburban station is used by over 1 million passengers per annum. Present-day services on the Midland main line are worked by East Midlands Railway and Thameslink – the last-mentioned company being responsible for stopping services which use the slow line platforms at stations such as Radlett.

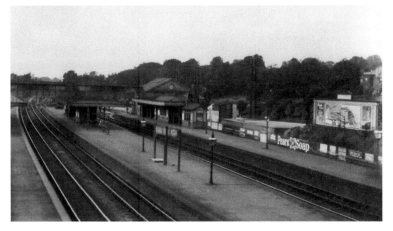

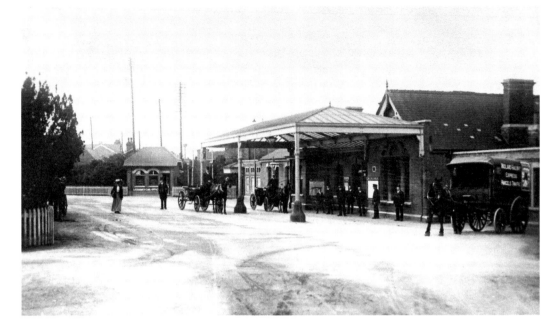

St Albans City

Now heading more or less due northwards, trains pass the site of a long-abandoned spur on the Down side which had once provided a connection between the Midland route and the nearby Watford to St Albans branch of the L&NWR. This obscure line was 1 mile 21 chains in length, and it appears to have been used by engineering trains during construction of the Midland route during the 1860s. Napsbury (18¼ miles) was the site of a small station that was opened in 1905 and closed with effect from 14 September 1959. St Albans, the next stop (20 miles from St Pancras), is a much more important place, with four platforms and a range of modern station buildings. Opened with the line on 13 July 1868, it is used by over 7 million passengers per annum. The station was known as St Albans City for many years, though it reverted to St Albans in 1988.

Opposite: **St Albans City**

Class 319 electric multiple unit No. 319060 leaves St Albans station while working the 2:56 Luton to Purley Network SouthEast service on 3 January 1990. The boarded-up and vandalised Midland Railway Type 2 signal box appears to be living on borrowed time in this photograph, but in fact it has survived until the present day, and this Grade II listed building is now in much better condition. After the box was closed in 1980, it became progressively more derelict until a local group was formed in 2002 to save it from destruction. It has now been superbly restored, complete with operating frame, and this characteristic Midland Railway structure is periodically opened to the public as a small museum.

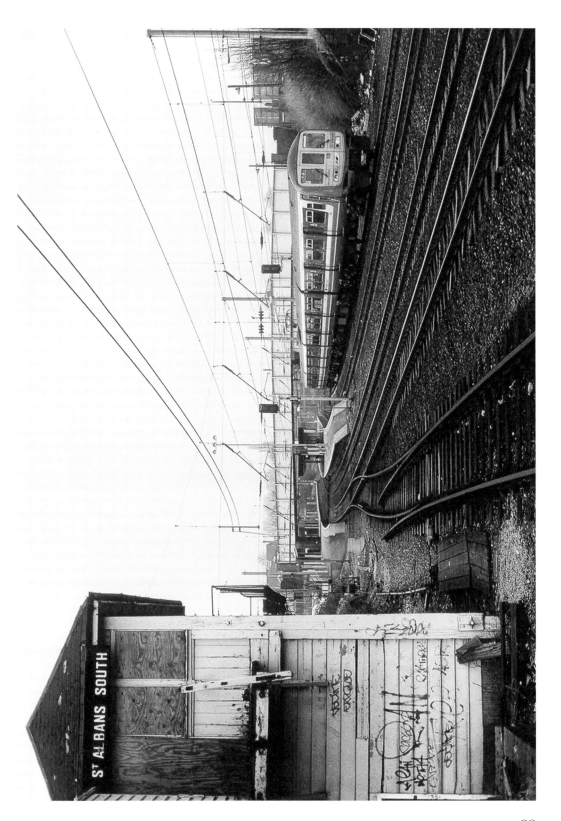

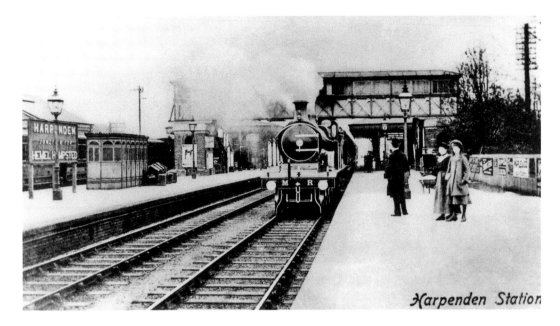

Harpenden Station

Harpenden Central

Harpenden (24¾ miles) was opened on 13 July 1868, and it became a junction on 16 July 1877 when the Hemel Hempstead Railway was brought into use. Although owned by an independent company, the Hemel Hempstead branch was worked by the Midland Railway from its inception. Passenger services were withdrawn in June 1947, but this relatively little-known line survived for many years as a 6-mile private siding, serving the needs of the Hemel Hempstead Lightweight Concrete Company, which conveyed up to 300 tons of specially treated ash over the line on a daily basis. The branch was finally closed in 1979. The photographs show Harpenden station in the early 1900s and during the LMS era around 1930.

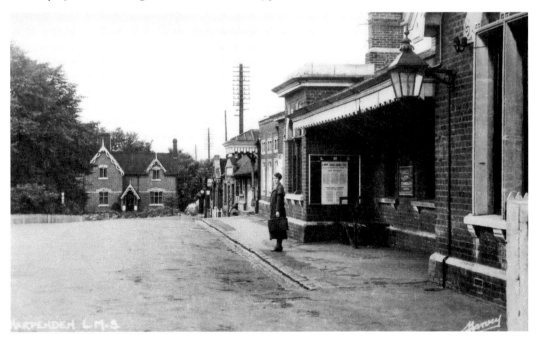

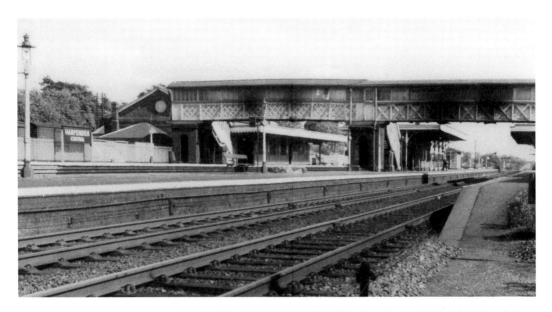

Harpenden Central

Above and centre: General views of the station during the British Railways period, *c.* 1962, showing the Up and Down fast and slow lines and the lattice girder footbridge. The station was known as Harpenden Central between 1950 and 1966.

Below: An unidentified Fowler Class 4MT 2-6-4T locomotive waits at Harpenden with a suburban train during the LMS era.

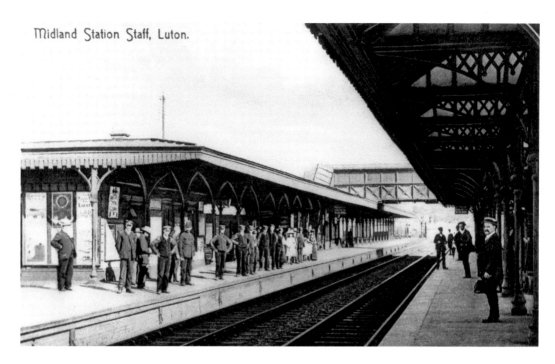

Midland Station Staff, Luton.

Luton Midland Road

Heading north-west along the multiple-tracked main line, trains run through pleasant Bedfordshire countryside passing, en route, the site of a closed station at Chiltern Green, which was in use from 13 July 1868 until April 1952. Chiltern Green Viaduct, to the south of the former station, is a brick arch bridge, but the slow lines bridge (to the east of the fast line) incorporates a mixture of brick arches and girder spans. Beyond, the route continues to Luton Airport Parkway (29¼ miles), which was opened on 21 November 1999. Luton, the next stopping place (30¼ miles), is just one mile further on. The photographs show this busy station during the Midland Railway era.

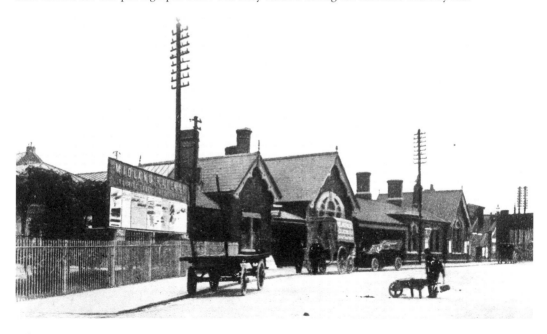

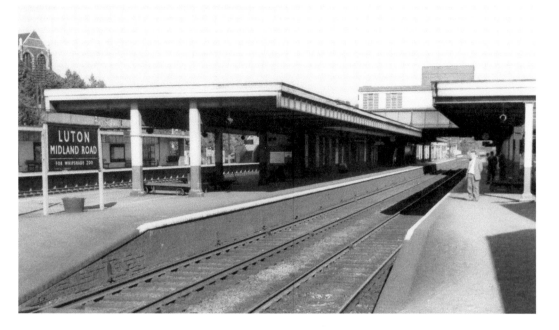

Luton Midland Road

This station was opened with the line on 13 July 1868, and extensively rebuilt under LMS auspices during the 1930s. The architect was William Henry Hamlyn (1889–1968), who had joined the London & North Western Railway in 1911 and subsequently became the Chief Architect of the LMS. There were, at first, only three platforms, but a fourth platform was added in 1960 and a fifth platform was installed during electrification work in the early 1980s in connection with the suburban services to and from St Pancras.

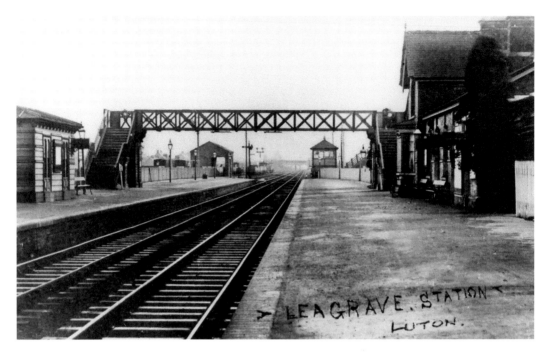

Leagrave

Heading north-west, Down trains soon reach Leagrave (32¾ miles), a wayside station that was opened with the line on 13 July 1868. The station, which remains in operation, is another typical Midland Railway stopping place with Up and Down platforms and a connecting footbridge, by means of which travellers are able to cross the running lines. The main station building is an L-plan cottage-style structure with a two-storey station master's house and a single-storey booking office. The booking office and waiting room are to the right of the house portion when viewed from the platform.

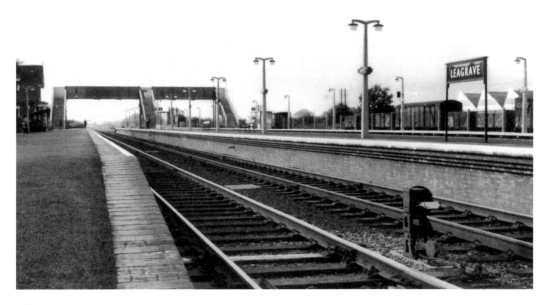

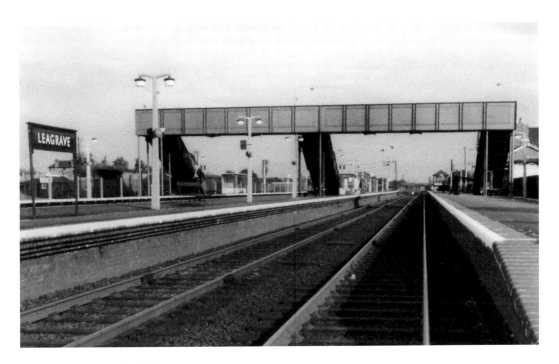

Harlington (Beds)

The upper picture provides a further view of Leagrave station during the BR era around 1962, while the lower view shows the next stopping place at Harlington (37¼ miles). In common with other local stations on the St Pancras route, Harlington was opened on 13 July 1868, and its facilities were progressively increased in connection with the widening of the line and other improvements. The station remains in operation and it is currently used by about 330,000 passengers each year.

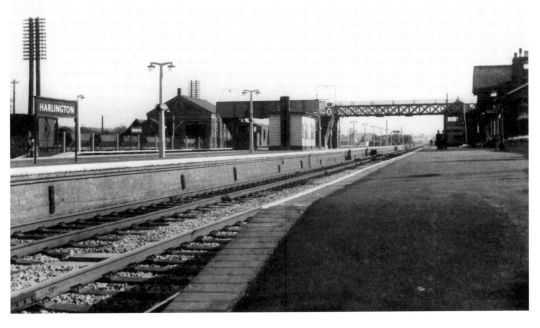

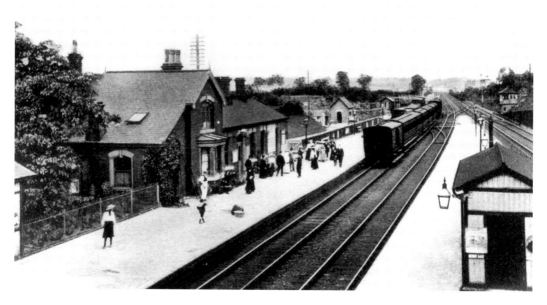

Flitwick

Having reverted to a northerly heading, trains reach Flitwick (40¼ miles), the next stopping place, which has been in use since 2 May 1870. Four platforms are provided here, the main station building being on the Down side, while the Up and Down sides of the station are linked by a plate girder footbridge. As usual on the St Pancras route, the main station building is of red brick construction, with a single-storey waiting room block and a two-storey cross wing containing domestic accommodation for the station master and his family.

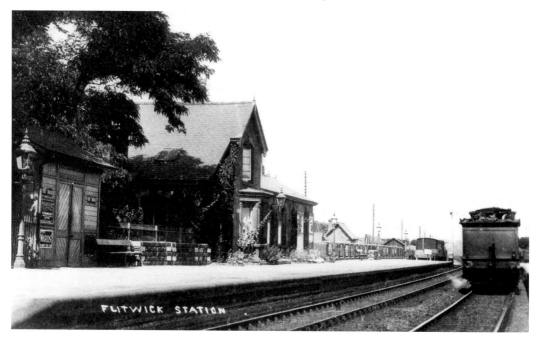

FLITWICK STATION

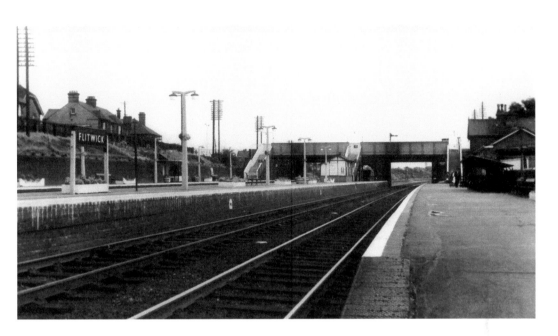

Flitwick

The accompanying photographs provide two additional views of Flitwick station during the British Railways period, around 1962. The cottage-style station building can be clearly seen together with the subsidiary building on the opposite platform, the latter structure being of timber-framed construction. The Midland employed Charles Liddell (1815–94) as engineer during the construction of the line between Bedford and a point to the south of Radlett. It seems likely that he would have been responsible for the cottage-style station buildings found on this section of the line, possibly in conjunction with the architect Charles Henry Driver (1832–1900), who also carried out a great deal of work for the Midland Railway.

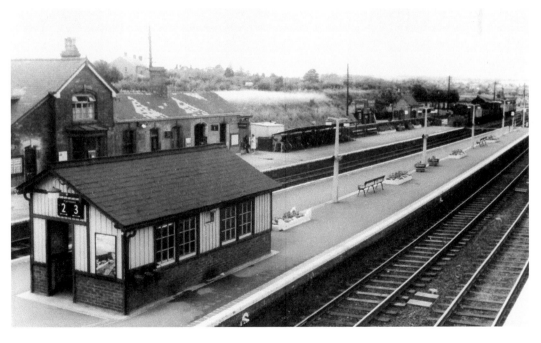

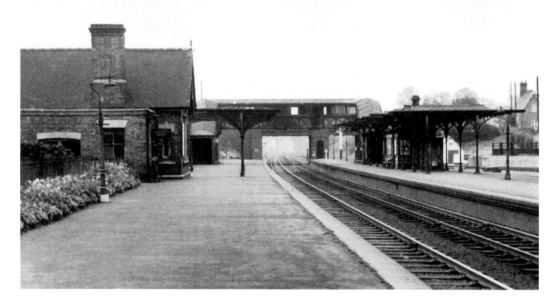

Ampthill

Still heading more or less due north, the route continues towards Ampthill (41¾ miles), the site of a wayside station that was in use from 13 July 1868 until its demise with effect from 4 May 1959. In architectural terms, the small-but-attractive brick station building reflected Midland practice on the St Pancras main line. The main building was a single-storey L-plan building incorporating a gable-roofed cross wing. The building followed no particular architectural style, though its tall chimneys and ornate fenestration conformed to the Victorian conception of a *cottage orné*.

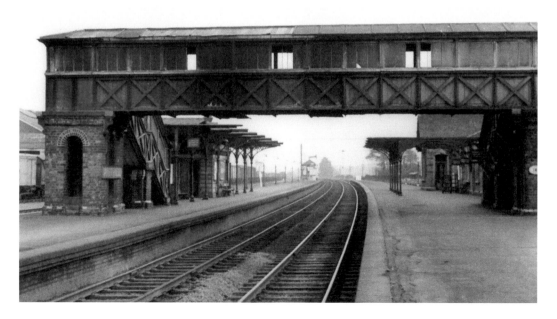

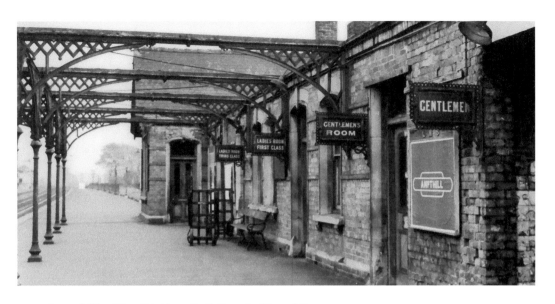

Ampthill – The Station Building & Signal Box

Above: A further glimpse of the main station building during its declining years. *Below*: A detailed view of Ampthill signal box, a standard Midland Railway all-timber cabin with a hipped, slated roof. Buildings of this same general type were found throughout the extensive Midland system, the basic design having remained more or less unchanged for many years. Study of the photograph will reveal that this example has half-height windows at each end and full-height windows at the front – a typical feature of Midland Railway signal boxes built between 1883 and 1901. Signalling enthusiasts generally refer to the 1883 cabins as Midland Type 2 boxes, whereas the 1901 cabins have been designated Type 3 boxes.

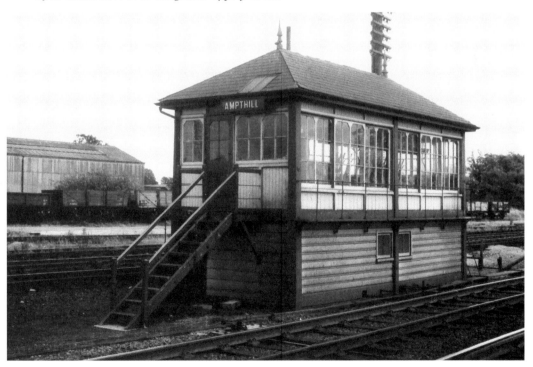

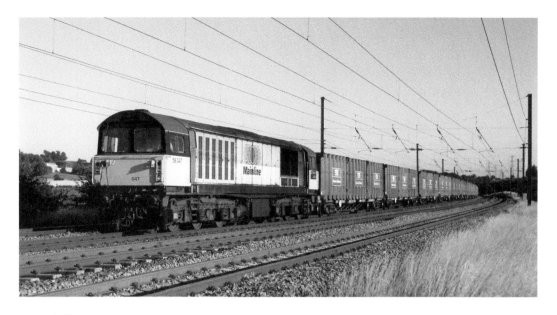

Ampthill

Above: Class 58 locomotive No. 58047 *Manton Colliery* heads northwards along the Midland main line near Ampthill with the 18:36 Cricklewood to Forders Shanks and McEwan 'binliner' service on 17 July 1996. The train will shortly be reversing at Bedford before heading down the Bletchley line to Forders, where it was due to arrive at 20:15. This refuse traffic has now ceased, as after many years of taking London's rubbish, the former brick pit is now full. *Below*: Class 58 locomotive No. 58027 ambles along the relief line at Ampthill with an overhead electrification train on 29 May 1988. Intensive use of the class on power station coal traffic during the week often gave way to easier duties such as this at the weekend.

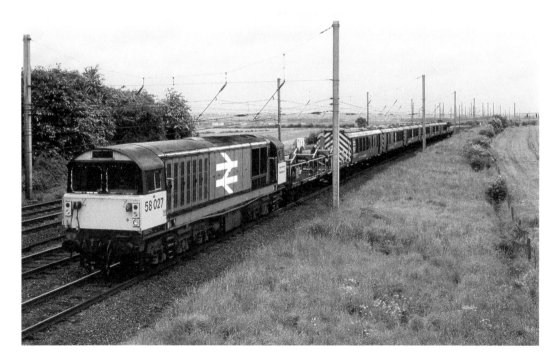

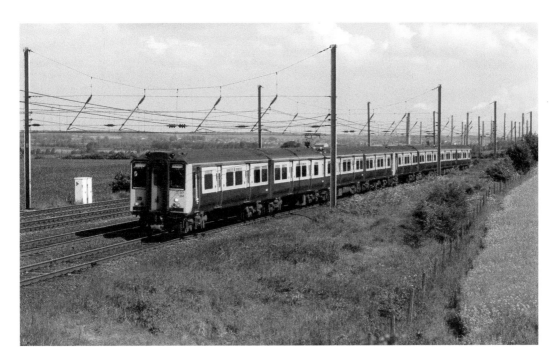

Ampthill

Above: Class 319 electric multiple unit No. 319047 heads an unidentified classmate past Ampthill on 8 June 1985 with the 08:50 Bedford to St Pancras service. The background is dominated by the chimneys of the Stewartby Brickworks. The Class 319 dual-voltage units were introduced in 1987–88 for use on north-to-south cross-London services. *Below*: Having reversed at Bedford, Class 47 locomotive No. 47016 passes Ampthill with the 10:45 Forders Sidings to Cricklewood empty binliner service on 2 November 1994.

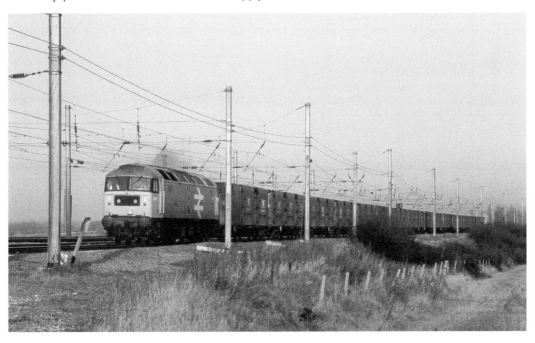

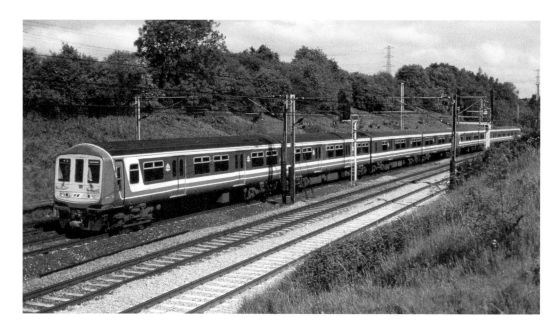

Ampthill

Above: A reminder of Network SouthEast days at Ampthill on 27 May 1989 as Class 319 set No. 319049 and an unidentified sister unit head through the Buckinghamshire countryside with the 09:52 Bedford to Brighton service. This is the point where the two sets of tracks separate, prior to entering the twin parallel bores of Ampthill Tunnel. *Below*: Wearing the minimalist 1990s Thameslink graffiti livery, Class 319 unit No. 319030 speeds past Ampthill with the 18:34 Moorgate to Bedford service on 17 July 1996. Curiously, the destination blind displays the name Luton, although the train had already passed through that station! Note the seventeenth-century Ampthill Park House, which is just visible in the background to the left of the train.

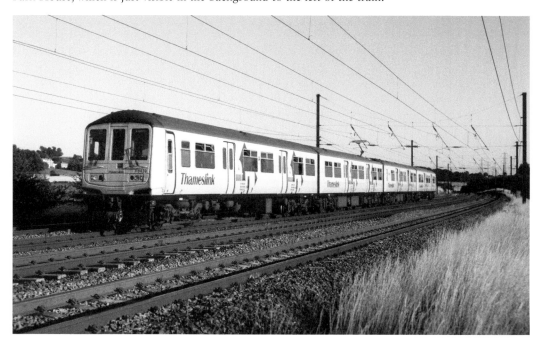

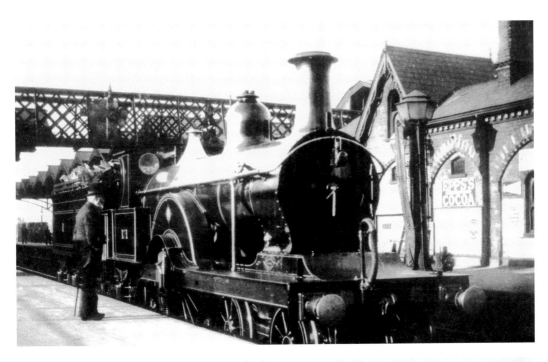

Bedford Midland Road

Continuing northwards, trains pass through the 759-yard Ampthill Tunnel before reaching Bedford (49¾ miles). Opened on 1 February 1859, this important intermediate station was known as Bedford Midland Road from 1924 until 1978. The first station had been a comparatively modest establishment, but its facilities were substantially altered and improved in connection with the opening of the London Extension in 1867–68. In July 1868 *The Leicester Chronicle* reported that the station had been 'much enlarged', the new facilities being 'in every respect in keeping with the other stations' on the Midland main line. The upper photograph shows a Johnson 4-2-2 single in the main platforms, while the lower view shows HST power car No. 43096 waiting to depart with a St Pancras express.

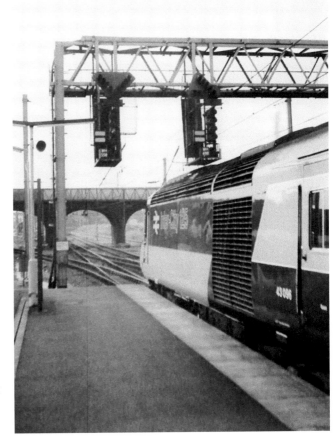

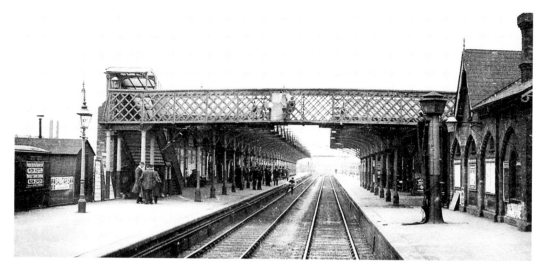

Bedford Midland Road

Major changes were put into effect at Bedford in 1890, when Up and Down fast lines were added on the west side of the platforms so that non-stop workings could bypass the station without impediment. Goods facilities were provided on a lavish scale. The main goods yard was sited to the south of the platforms on the Up side, and it contained a two-storey goods shed and an array of sidings, the yard crane being of 10-tonne capacity. The 1938 Railway Clearing House *Handbook of Stations* lists a number of private sidings in and around the station, including W. H. Allen & Sons' siding and the Bedford Gas Company siding. Bedford motive power depot was sited to the south-east of the passenger station. The normal allocation during the British Railways period was about forty locomotives. The shed building was a four structure, while the usual coaling stage, offices, mess room and turntable were provided. The shed was coded 15D from 1948 until 1958, and 14E from 1958 until 1963. The shed was closed in 1963, by which time it had been recoded 14C.

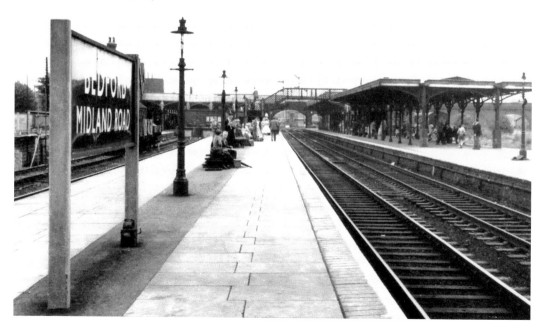

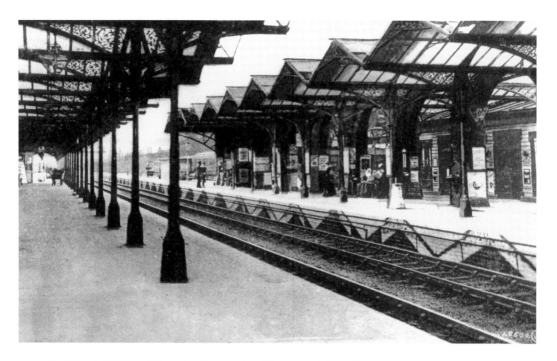

Bedford Midland Road – Some Architectural Details

In architectural terms, the main station building was a brick-built structure in the vernacular style and, as such, the building was similar to the other stations provided on the St Pancras main line. The main block was of just one storey, but the cross wings were of one-and-a-half stories with elaborate barge boards. The platforms were covered, for much of their length, by glass and iron canopies. The roof coverings were supported by upright pillars with elaborate spandrels, as shown in the upper photograph. In its report on the opening of the new station, *The Leicester Chronicle* stated that 'the light ironwork and glass roof of the arcades' displayed great taste – the building being 'altogether satisfactory'. The new station was also said to have been much admired for the 'completeness of the suite of waiting rooms and offices', as well as 'the elegance of the design'.

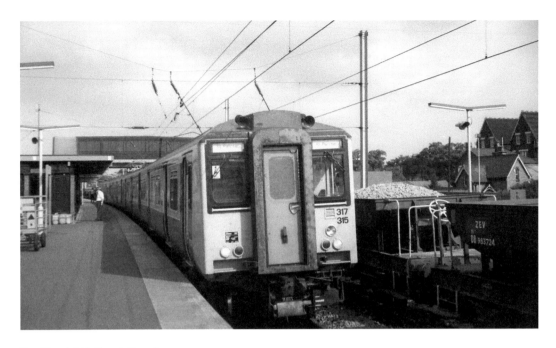

Bedford Midland Road

Bedford's railway infrastructure was rationalised during the 1960s, and by the end of that decade the passenger station had been reduced to just two platforms for Up and Down traffic. However, the station was remodelled during the 1970s, when BR constructed what was in effect an entirely new station a short distance to the north of the 1859 station. In connection with this rebuilding scheme, the Up and Down slow lines were moved further to the west, and a new island platform was installed on the Down side, although Up services continued to use the old Platform 1 until the new one was completed. The photographs show Class 317 unit No. 317315 in the rebuilt station during the early 1980s. These four-car electric multiple units were introduced in 1981–82 for service on the St Pancras to Bedford route.

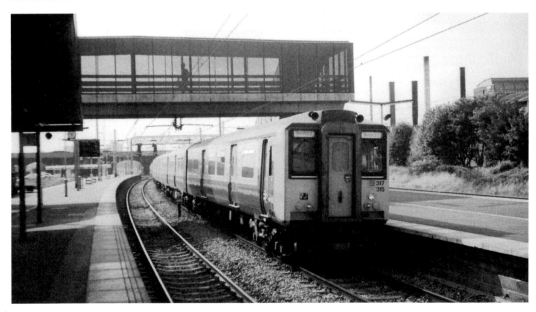

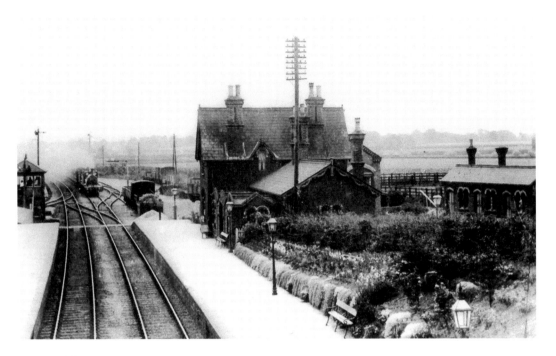

Oakley

On leaving Bedford, trains run north-westwards to Oakley (53 miles) – the site of a small station that was in operation from 8 May 1857 until 13 September 1958. The upper view shows this archetypal country station during the early years of the twentieth century, while the lower picture shows HST power car No. 43043 passing the site of the station while forming the 07:05 Sheffield to St Pancras service on 16 August 2007. Like other Midland stations on the St Pancras main line, this wayside station was provided with attractive, cottage-style buildings of the now-familiar type, together with a standard MR Type 2 signal cabin.

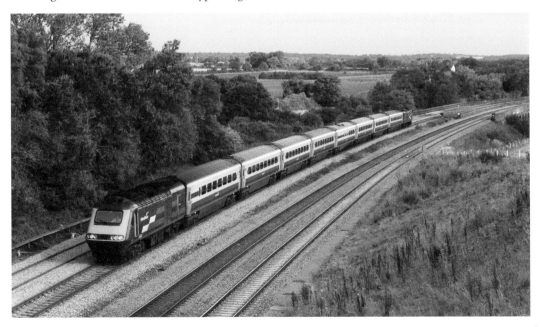

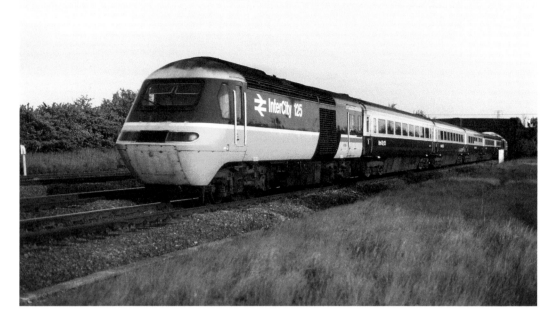

Oakley

Above: HST power car No. 43014 catches the last rays of the evening sunlight as it speeds northwards past Bromham, near Oakley, with the 18:00 St Pancras to Nottingham service on 4 May 1987. Note the ghost image of the locomotive's number under the windscreen. *Below*: Class 40 locomotive No. D200 passes Bromham with the Traintours St Pancras to Preston 'Corby Cutler' railtour on 4 May 1987. At this time No. D200 was the last remaining Class 40 locomotive on the main line, having been retained in service primarily for railtours such as this. The locomotive retired in the following year, after thirty years of service.

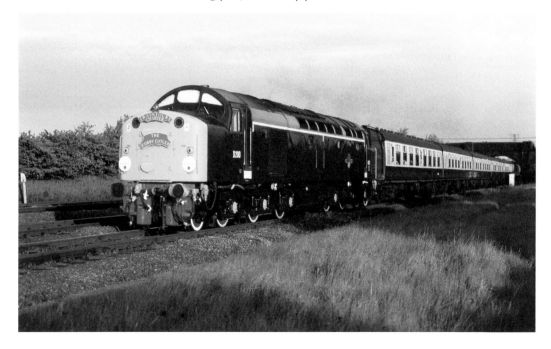

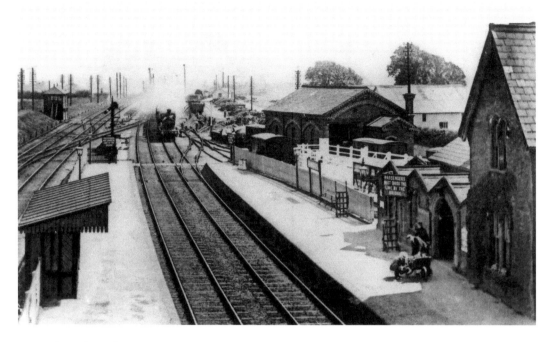

Sharnbrook

Above: Sharnbrook station (56¾ miles) was opened with the line on 8 May 1857 and closed with effect from 2 May 1860. *Below*: Class 222 Meridian unit No. 222003 passes Milton Ernest, near Sharnbrook, with the 09:30 Nottingham to St Pancras service on 16 August 2007. Class 222s come in four-, five- or eight-coach formations, as shown here. The train has crossed over the River Great Ouse, which the line repeatedly crosses and re-crosses in the Bedford area. The tracks on the right are the slow lines, which take a different alignment in the vicinity of Sharnbrook in order to provide easier gradients for freight workings on the climb to Sharnbrook Summit. The summit itself is to the north of the station at milepost 59¾.

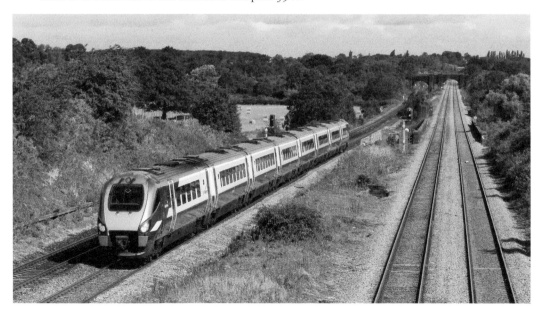

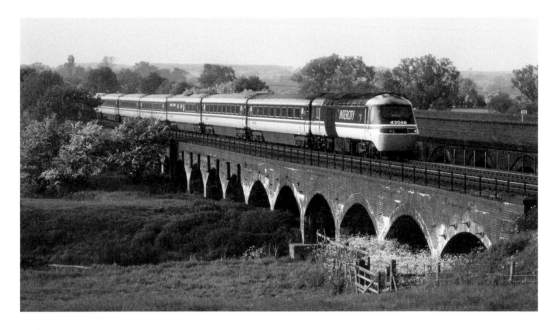

Irchester

Above: An HST set headed by power car No. 43048 crosses the viaduct over the River Great Ouse at Radwell, in soft evening light, on 21 May 1989 with the 07:38 Nottingham to St Pancras InterCity service. This is the second of seven crossings of the Great Ouse in the short distance between Sharnbrook and just south of Bedford station. Irchester station (62¾ miles) was opened on 8 May 1857 and closed with effect from 7 March 1960. *Below*: Under an impressively dark sky, HST power car No. 43066 *Nottingham Playhouse* crosses the River Nene near Irchester with the 08:35 Leeds to St Pancras Midland main line service on 15 December 2001. The houses of Wellingborough can be clearly seen in the background, together with the Victorian Gothic St Mary's church.

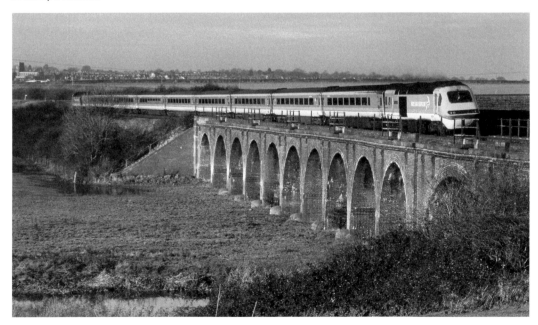

Wellingborough Midland Road, the next stopping place (65 miles), was opened on 8 May 1857, its original name being simply 'Wellingborough'. Prior to rationalisation the station had boasted five platforms – the Midland main line through Wellingborough having been quadrupled in 1882. The Down slow platform was formerly equipped with a bay platform for Higham Ferrers branch trains, and this was regarded as Platform 3, while Platform 4 was the northern end of the same platform. At the present time the station has three platforms, Platform 1 being on the Down (or west) side, while Platforms 2 and 3 are the two sides of an island platform.

The main station building, on the Down side, is a picturesque Victorian structure in the usual vernacular style and, as such, the building is very similar to the other stations provided on the St Pancras main line. The main block, which is arranged on a parallel alignment to the platforms, is of just one storey, but the gabled cross wing at the north end is of two stories, with elaborate pierced bargeboards and finials. The building, which was designed by the architect Charles Henry Driver, is solidly constructed of red brickwork, with contrasting white and blue brick and sandstone dressings.

The platforms are covered by glass and iron canopies. The roof coverings are supported by upright pillars with elaborate spandrels. In its report on the opening of the Leicester & Hitchin line, published on Saturday 9 May 1857, *The Leicester Chronicle* praised the 'simplicity of design and modest tastefulness' of Wellingborough and the other intermediate stations, which displayed 'a judicious mean between paltriness and ostentatiousness' and resulted in a series of buildings that were 'unique and pleasing in character'.

The island platform was equipped with a smaller building of less elaborate design, which was probably built when the station was enlarged in the 1890s. Several ancillary buildings were added during the early twentieth century, including a telegraph office on Platform 1 and a Permanent Way Inspector's office on the east side of the station.

Goods facilities were provided on a fairly generous scale, with sidings on both sides of the running lines. The Down side goods yard, which was sited to the west of the platforms, contained a large brick-built goods shed, cattle loading pens and other facilities, while the yard crane was of 5-tonne capacity.

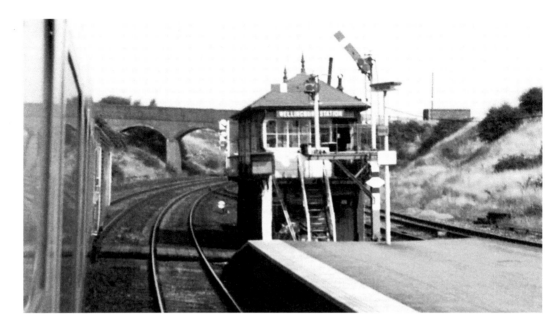

Wellingborough Midland Road

Above: The passenger station was signalled from two signal boxes, Wellingborough Station Box, a standard MR cabin, being sited at the north end of the station, while Wellingborough Midland Junction Box was sited to the south of the platforms. The Station Box was erected in 1893, whereas the Junction Box was of more recent origin, being a wartime 'ARP' (Air Raid Precaution) box that had replaced an earlier cabin in 1943. Wellingborough Junction Box was taken out of use on 13 November 1983, while Wellingborough Station Box was closed on 5 December 1987 in connection with the Leicester Gap resignalling scheme, which involved the resignalling of 55 miles of line between Irchester and Loughborough and the elimination of twenty-three manual signal boxes. *Below*: HST power car No. 47833 heads northwards through Wellingborough with the BR InterCity 09:00 St Pancras to Derby 'Chatsworth' luxury charter on 13 June 1992.

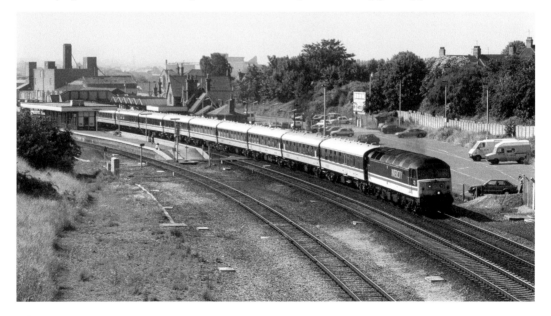

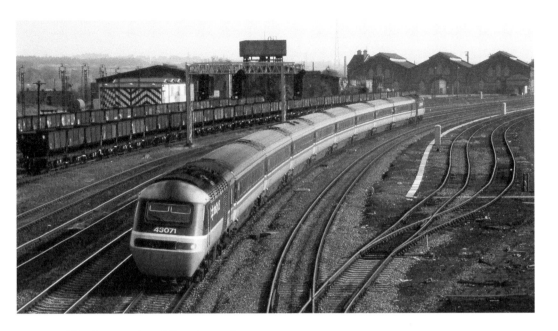

Wellingborough Midland Road

Above: HST power car No. 43071 accelerates away from Wellingborough station and passes beneath the Finedon Road with the 16:35 St Pancras to Nottingham service on 21 May 1989. The former steam shed can be seen in the background, together with lines of redundant HTV hoppers being stored in the sidings. The infrastructure provided at this busy location included two large roundhouses, together with the usual coaling stage, offices and mess rooms. The normal allocation during the early British Railways period was about seventy locomotives, most of these being freight engines. In 1950, for example, the allocation comprised seventy-seven engines, including forty-seven Stanier Class 8F 2-8-0s, four Class 3F 0-6-0s, nine Class 4F 0-6-0s and eleven Class '3F' 0-6-0Ts. *Below*: Rakes of redundant hopper wagons fill the sidings as power car No. 43066 sweeps through Wellingborough with the 15:54 Sheffield to St Pancras service on 21 May 1989. The sidings have latterly been used for the storage of ballast wagons.

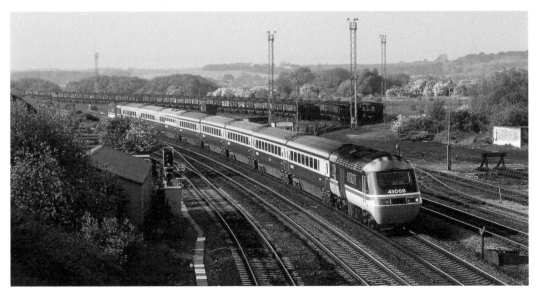

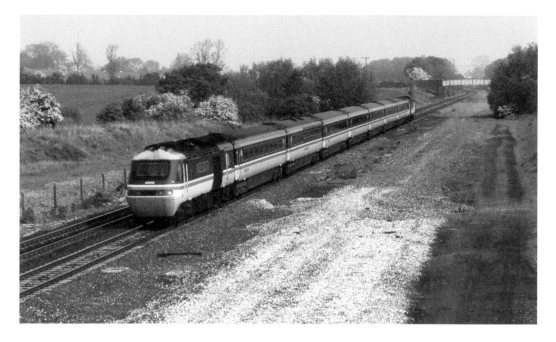

Finedon

From Wellingborough, the multiple-tracked Midland route runs northwards on gently rising gradients to Finedon (68¼ miles). This station was opened in July 1857 and closed to passengers in December 1940, although goods traffic survived until 1964. The upper view shows an HST set headed by power car No. 43105 passing the site of Finedon station with the 08:33 Nottingham to St Pancras InterCity service on Sunday 21 May 1989. Note the non-standard small front number. The lower view shows Class 45 locomotive No. 45052 passing Finedon with the 07:43 Hertfordshire Railtours St Pancras to Carlisle Thames-Eden service.

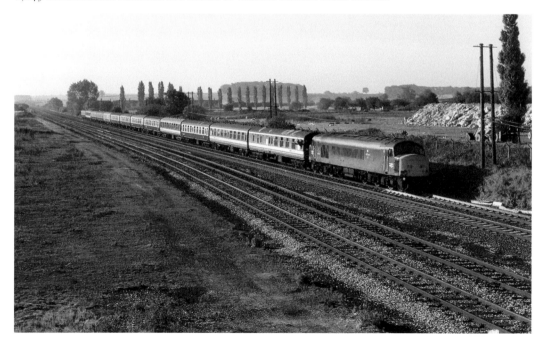

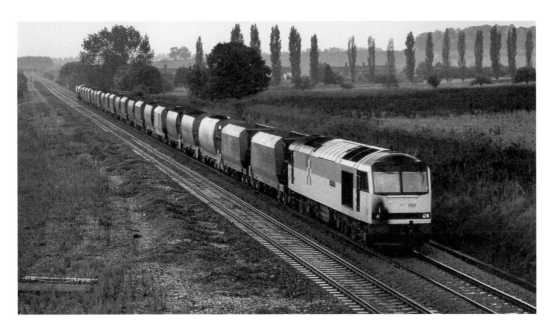

Finedon – Freight Trains

Above: Class 60 locomotive No. 60080 *Kinder Scout* could certainly do with a front end wash as it passes the site of Finedon station with the 13:09 Radlett to Mountsorrel Redland stone empties on 1 October 1994. It is unclear what has caused such localised soiling, as the rest of the locomotive seems reasonably clean. Finedon station was not exactly convenient for the local population, being a considerable distance from the village of that name – in fact the station was actually closer and more convenient for the neighbouring village of Burton Latimer! *Below*: Sister engine No. 60011 *Cader Idris* passes Finedon with the 08:37 Mountsorrel to Radlett Redland stone train on 1 August 1992. The spacious track formation here indicates the site of the former goods lines.

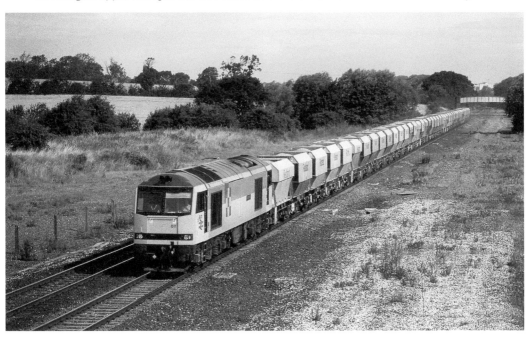

Kettering, 72 miles from St Pancras, was opened on 8 May 1857, when the Leicester, Bedford & Hitchin line was brought into use. Like other stations on the Leicester to Bedford route, Kettering started life as a relatively unimportant stopping place, but subsequent traffic growth ensured that the original facilities were progressively increased. The line through Kettering was, like most of the Midland main line, increased to four tracks during the late Victorian period, with separate Up and Down lines for fast and slow traffic. The quadrupling was completed between 1889 and 1895, the four tracks being continued as far as Glendon, a little under 75 miles from London.

The layout at Kettering provides four platform faces, the centre platform being an island with tracks on both sides. The platforms were numbered from 1 to 5, the centre island comprising Platforms 3 and 4. This platform was equipped with wooden buildings and ridge-and-furrow canopies, while a further example of Midland Railway canopy construction could be seen on Platform 5. These structures incorporated two distinct periods of construction, the original station building and canopy having been designed by C. Biddle during the 1850s, while various additions were made when the station was reconstructed during the 1890s.

There were three signal cabins in the vicinity of Kettering station, the main station box being sited between the fast and slow lines to the south of the platforms. Kettering North Box was on the Up side, just two chains further north, while Kettering South Box was sited on the Down side, to the south of the station.

Kettering Shed (15B in BR days) was sited alongside the slow lines on the east side of the platforms, the shed building being a four-road structure with a double-gabled roof. It contained the usual coaling and watering facilities, together with a 60-foot-diameter locomotive turntable that had been installed by the LMS in 1938 to facilitate the introduction of the Stanier class 5MT 4-6-0s and other large engines. In early British Railways days, the shed housed an assortment of around thirty-eight locomotives, including a large allocation of Class 8F 2-8-0s for hauling the heavy ironstone trains that were so much a feature of the local railway scene. These sturdy ex-LMS locomotives were subsequently joined by a number of British Railways Standard Class 9F 2-10-0s, which were ideally suited for hauling trains of iron ore. The station was able to handle all types of goods traffic including coal, livestock, vehicles, furniture and general merchandise. A large, red brick goods shed was sited immediately to the east of the passenger station, and a 10-tonne yard crane was able to deal with large or bulky consignments.

Kettering was a relatively complex station and, in addition to its role as the junction for branch services to Huntingdon and Cambridge, it also served as the junction for a short mineral line known as the Loddington Branch. The last-mentioned line diverged westwards on the Down side of the running lines, and extended for 3 miles 65 chains, serving, en route, the Cransley Iron & Steel Company's works and the Loddington Iron Company.

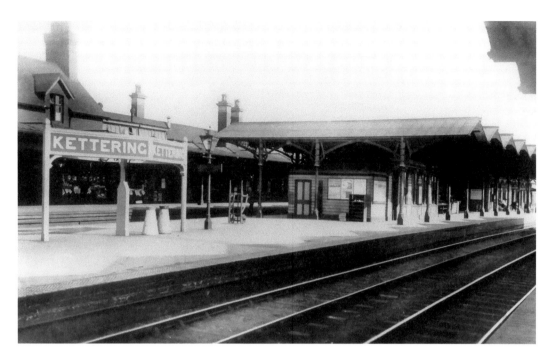

Kettering

Above: A general view of Kettering station, probably photographed during the LMS period, around 1930. *Below*: Consecutively numbered Class 33 locomotives Nos 33021 and 33022 round the curve at Kettering at the head of the 11:00 Leicester to St Pancras (via Corby) special on 21 May 1989. This was one of a number of Hertfordshire Railtours special trains using freight motive power, which were promoted as the 'InterCity Diesel Day'.

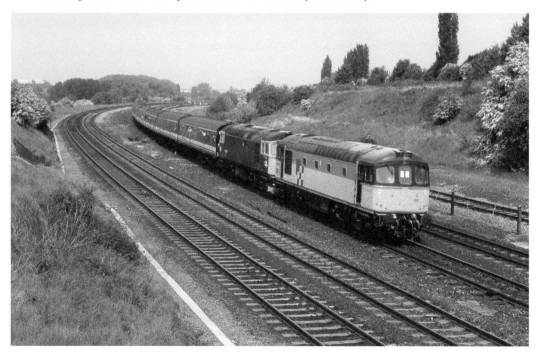

Heading north-west, the railway descends towards Market Harborough (83 miles) on falling gradients of 1 in 132 and 1 in 133. This station served as an interchange between the London & North Western and Midland systems, the North Western line from Rugby having been opened on 1 May 1850, while the L&NWR was joined by the Midland route from Leicester to Hitchin on 8 May 1857. Less than two years later, on 16 February 1859, the L&NWR opened a direct route from Northampton, and in 1879 Market Harborough also became a junction for services on the Great Northern & London & North Western Joint line, which left the original L&NWR route at Welham Junction to the north of the station. The station was extensively rebuilt in the 1880s in order to cater for the traffic generated by these additional lines. The station itself was owned by the London & North Western Railway, but the Midland paid contributions for the use and maintenance of the shared facilities.

The station was orientated from north to south, the L&NWR lines being on the west side while the Up and Down Midland lines were to the east. Up and Down platforms were provided for both companies, the Up L&NWR and Down Midland lines forming the two sides of a V-shaped island platform. Additional bays were available for Up and Down North Western trains, while both sets of platforms were bypassed by separate goods lines. The platforms were at high level, with subway connections from the main low level station building.

As one might expect at a location shared by two companies, Market Harborough was well-supplied with goods facilities. There were two yards on the L&NWR side of the station, one of these being primarily a coal depot while the other handled general goods traffic. A separate range of accommodation was provided on the Up side of the Midland line, the Up yard being equipped with a goods shed and coal sidings. In addition, there was an array of parallel exchange sidings between the Down Midland and Up L&NWR running lines, these sidings being laid out as a system of loops with connections at each end.

There was a further profusion of facilities in terms of signalling, no less than seven signal boxes being in commission at one time. In later years the signalling arrangements were considerably rationalised, the former Midland South Box being replaced by a ground frame in January 1931, while at the same time a new No. 2 Box replaced two earlier cabins that had formerly been situated to the north of the platforms. These LMS alterations left three boxes in commission, while by 1986 only one remained, and this was abolished as part of the Leicester Gap re-signalling scheme. Market Harborough was also the site of a small engine shed, which was situated to the west of the L&NWR goods yard on the Down side of the running lines.

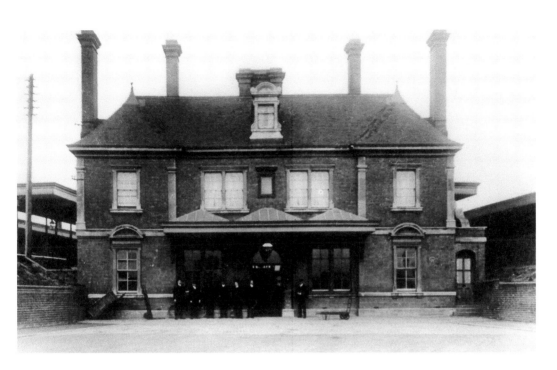

Market Harborough

Above: The station building is perhaps the most attractive feature of the entire station. Dating from the rebuilding that had been carried out in 1883–84, it was sited in the 'V' of the diverging centre platforms. The building was a relatively large, two-storey structure with a hipped roof; it was of brick construction with a tiled roof, the overall architectural style being reminiscent of the later seventeenth century. The ground floor contained a booking hall and ticket office, together with offices for the Midland and North Western station masters, while ramps and covered stairways provided a means of access from the booking hall to the high-level platforms. *Below*: A view of the platforms prior to reconstruction. There are now just two platforms, and these are sited to the north of the distinctive station building.

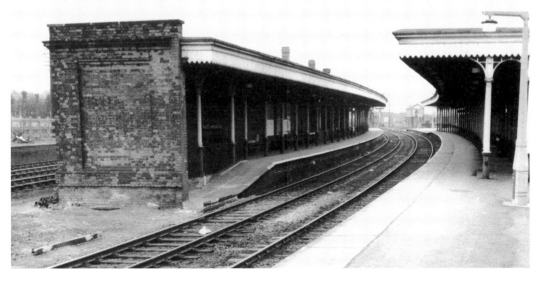

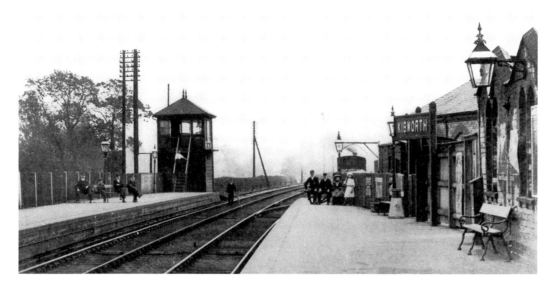

Kibworth

On leaving Market Harborough, trains run through pleasant countryside for a little over two miles to East Langton (86½ miles). This was not an original stopping place, having been opened on 2 October 1876. The station, which was closed with effect from 1 January 1968, was situated on an embankment, and perhaps for this reason its buildings were of timber-framed construction. From East Langton, the railway runs north-west towards Kibworth (88¾ miles), another typical Midland Railway stopping place with Up and Down platforms and a brick-built overbridge immediately to the north. The bridge was equipped with stairways and a connecting footbridge, by means of which travellers were able to cross the running lines. The main building, on the Down side, was very similar to its counterparts at Oakley and Flitwick, being an L-plan structure with a two-storey station master's house and a single-storey booking office, the booking office and waiting room being to the left of the house portion when viewed from the line. Kibworth station was in use from 8 May 1857 until closure with effect from 1 January 1968, although goods traffic was handled until 1966 and the signal box remained in use until 1986.

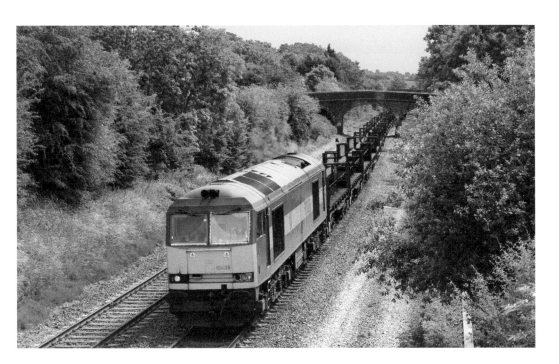

Kibworth

Above: Class 60 locomotive No. 60026 passes Kibworth Harcourt with the 10:10 Corby to Margam steel empties on 25 June 2008; the train is travelling via the Midland main line rather than its usual route via Melton Mowbray. *Below*: HST power car No. 43061 leads the 08:28 Leeds to St Pancras East Midlands Trains service past Kibworth Harcourt on 25 June 2008. The railway line here actually divides the village of Kibworth Harcourt from neighbouring Kibworth Beauchamp, which perhaps explains why the Midland Railway decided to call their station Kibworth.

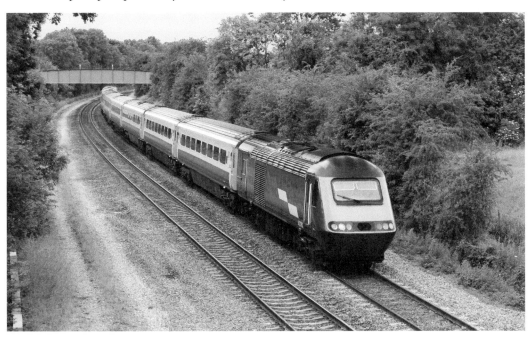

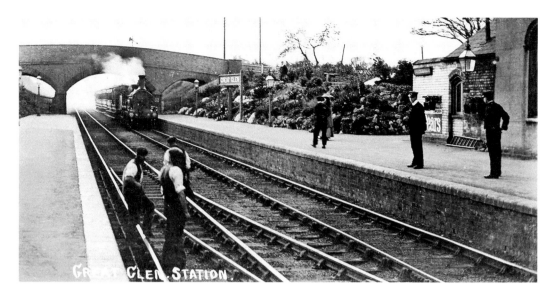

Great Glen

With the Grand Union Canal maintaining a more or less parallel course on the left-hand side, the railway passes the picturesque village of Newton Harcourt. There was, however, no station here, and the inhabitants of the village had to make do with a station at nearby Great Glen (91¼ miles), which was opened on 8 May 1857 and closed with effect from 18 June 1951; this rural stopping place was known simply as 'Glen' for many years. The brick station building was on the Up platform, and there was a much smaller building on the Down side. The Up and Down platforms were linked by a barrow crossing, and there was a triple-arched brick overbridge immediately to the west of the platforms. The goods yard, which was on the Up side of the running lines, contained coal wharves and a cattle loading dock, while the standard Midland hipped-roof signal cabin was sited on the opposite side of the line. The photographs show the station during the early 1900s, the locomotive that can be seen in the lower view being Johnson Class 3 4-4-0 No. 758.

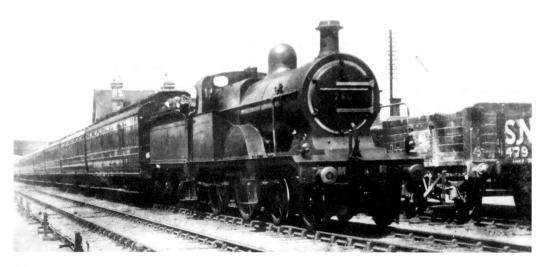

Wigston station (95¼ miles) was opened in 1857, at which time the surrounding area had been entirely rural in character. The original station was merely a wayside stopping place, but this station was superseded at the end of the Victorian period, when the line through Wigston was widened and the earlier station buildings were removed. The new facilities consisted of Up and Down platforms, with by-pass lines on either side and a road overbridge to the north. The main station building, on the Down side, was a two-storey brick structure, which abutted the overbridge in order that the public entrance could be placed at first floor level. A covered stairway led down to platform level, while a similar covered stairway provided a means of public access from the bridge to the Up platform.

Curving northwards, Down trains reach Wigston South Junction, where a direct west-to-east curve from the former L&NWR South Leicestershire line converges from the left. The junction was formerly controlled from Wigston South Junction Signal Box, which was situated on the Up side of the running lines. Although of standard Midland Railway design, this cabin was distinguished by a projecting upper storey, which was cantilevered out over a narrow locking room. A further standard MR signal cabin, known as Wigston North Junction, was sited just 31 chains further on to control the northern end of a triangular junction; all of these mechanical boxes were abolished in 1986 as part of the Leicester Gap resignalling scheme.

To the east, curious travellers may have noticed the site of a former Midland Railway engine shed beside the Up main line sidings. This little-known shed was closed by the LMS in 1934, and its locomotives were transferred to Leicester Midland shed. However, Wigston South was reactivated as a stabling point when the main Leicester sheds were being rebuilt in 1952. There were sidings on both sides of the running lines, and these were at one time controlled from two signal cabins known as Wigston Up Sidings and Wigston Down Sidings boxes.

Heading due north, the line continues through the sprawling outer suburbs of Leicester for over three miles passing, en route, over an impressive, slightly curved embankment, and then over Knighton Lane on an arched brick viaduct. Emerging from the 104-yard Knighton Tunnel, trains pass beneath a substantial road overbridge that carries the busy Welford Road across the line. There was formerly a small station at Welford Road, which adjoined Leicester Cattle Market. This facility was opened in 1874, and it incorporated a siding connection on the Down side, by means of which cattle traffic could be worked into the market area. Curiously, there was just one platform for passenger traffic on the Down side, which meant that trains could call in one direction only. The station also served as a ticket platform until its closure in 1918.

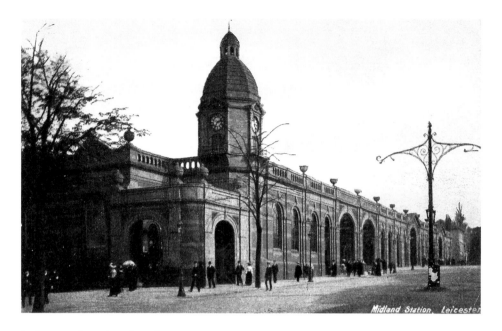

Leicester London Road

Situated some 99 miles from St Pancras, Leicester London Road station has a spacious twin-island layout, with four long platforms and extensive buildings at both platform and street level. The main buildings are sited above the platforms on the London Road bridge, while connecting footbridges and stairways give access to the platforms. In its modern form, Leicester London Road dates mainly from the late nineteenth century, the Midland Railway having carried out a major rebuilding programme at that time. The distinctive station buildings were designed by Charles Trubshaw (1840–1917) and opened in 1892. They incorporate a huge porte cochère flanking London Road, through which travellers pass into a spacious circulating area with access to the booking office and other facilities. The street level frontage sports an ornamental balustrade, with a domed clock tower at one end, and large arched entrances, above which were displayed the words arrivals and departures.

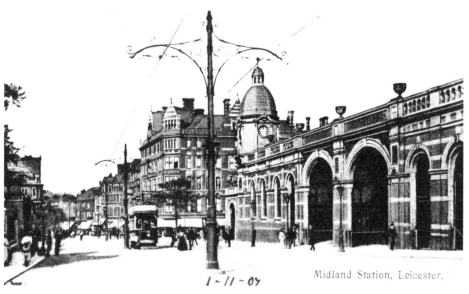

1-11-07 Midland Station, Leicester.

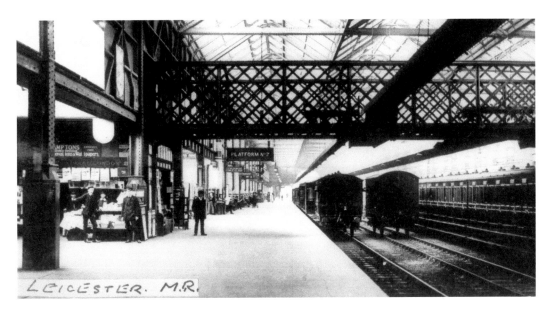

Leicester London Road

The four platforms are laid out from north to south, with the London Road Bridge at one end and Swain Street Bridge at the other. The platform faces are numbered in sequence from 1 to 4, Platforms 1 and 4 being the two outer roads, while Nos 2 and 3 ran through the middle of the station. Both platforms are equipped with modern buildings, which were constructed in the 1970s as part of a reconstruction scheme. Until recent years the station had boasted an overall roof, formed of three huge, longitudinal spans, two of which covered the island platforms while the middle span was situated over the centre tracks. The upper photograph shows the station in Edwardian days, while the lower view shows an HST set at Leicester during the 1980s.

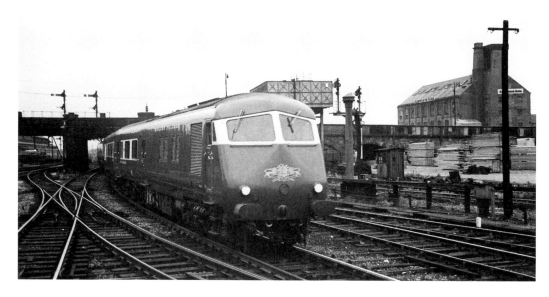

Leicester London Road – Diesel Power

On 4 July 1960 BR introduced a de-luxe 'Blue Pullman' service, two six-car diesel multiple unit sets being allocated to the Midland route, while two eight-car units were allocated to the Western Region. The Midland sets covered the 189-mile journey between Manchester and St Pancras in 3 hours 13 minutes in the Up direction and 3 hours 11 minutes in the Down direction. A second service was provided in the early afternoon between St Pancras and Leicester, but this was so poorly patronised that BR extended the afternoon service to Nottingham, with an intermediate stop at Loughborough. Loadings were so disappointing that BR withdrew the Nottingham service in 1961, although the Manchester workings remained in operation until 1966. The upper photograph shows the 'Midland Pullman' entering the station, while the lower view shows a Class 45 locomotive at Leicester around 1976.

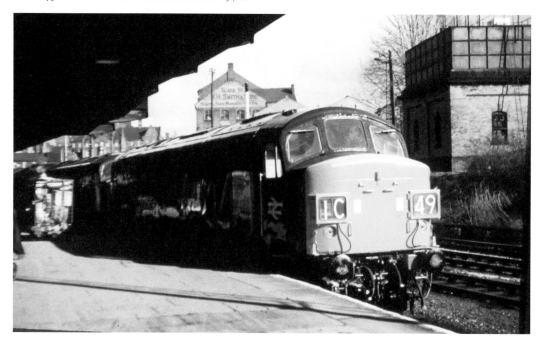

Leicester London Road

Right: An atmospheric scene on the platforms at Leicester London Road around 1980.
Below: A further selection of tickets from the southern section of the Midland main line between Radlett and Leicester, including three platform tickets and six BR second class travel tickets. Traditional Edmondson card tickets were colour-coded, second class tickets being printed on greyish-green cards, while first class issues were normally white.

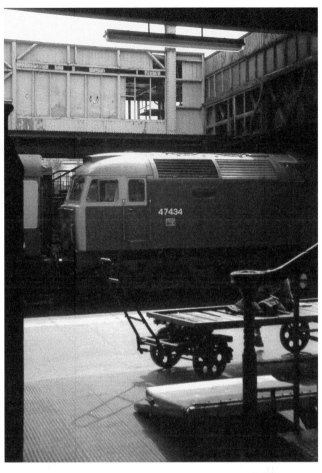

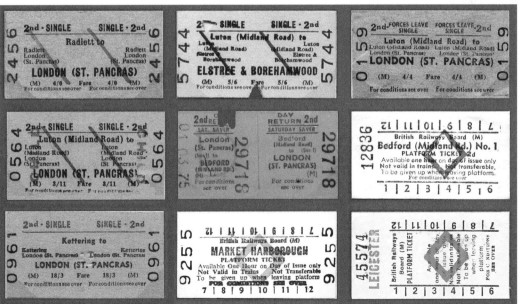

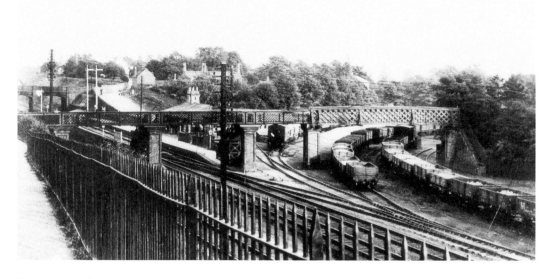

Barrow-on-Soar

Resuming their northward journeys, trains pass a number of former stations, including Syston (103¾ miles), Sileby (106¾ miles) and Barrow-on-Soar (109 miles). These stations were opened with the line on 4 May 1840 and closed by BR with effect from 4 March 1968 but, happily, all three were reopened on 22 May 1994. The upper view shows Barrow-on-Soar station during the early years of the twentieth century, and the colour photograph, taken on 15 September 2012, shows Class 222 Meridian unit No. 222010 speeding past Barrow-on-Soar with the 11:47 Sheffield to St Pancras service. In August 2019 the East Midlands train operating company was replaced by the East Midlands Railway, and these units are now being repainted in EMR purple livery.

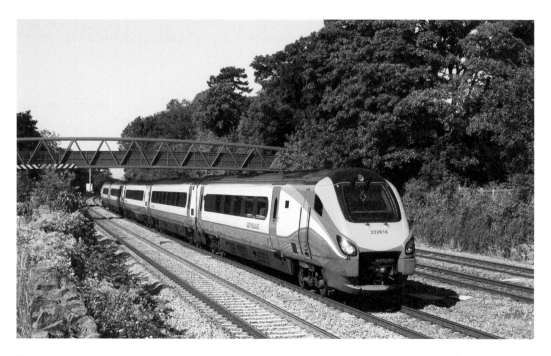

Situated some 111½ miles from St Pancras, this station was known as Loughborough Midland for over eighty years, though in 1970 it became simply Loughborough. In its present-day guise, the station has three platform faces – Platform 1 being the main Down platform, while Platforms 2 and 3 form the two sides of an island platform on the east side of the station; Platforms 1 and 2 can accommodate ten-coach trains, whereas the slightly shorter Platform 3 can handle trains of up to seven coaches. The platforms are linked by a footbridge, while Nottingham Road is carried across the line on a two-span bridge at the London end of the platforms, one of the spans being a brick arch, while the other has a girder span. A further bridge, sited immediately to the south of the road bridge, formerly carried the Great Central main line across the Midland route – the GCR bridge being a brick-and-girder structure with four spans.

In architectural terms, Loughborough is a more or less complete Victorian station that dates, in the main, from a major rebuilding programme that was carried out by the Midland Railway during the early 1870s. The main station building on the Down side is of yellowish-white brickwork with brown brick dressings and a hipped roof – the general appearance being Italianate in character. The prominent central block, containing a spacious booking hall, is flanked by projecting wings, while the windows and doorways at the rear of the building are boldly arched. The subsidiary building on the Up side is similar to the main building, being a single-storey Italianate structure with a low-pitched slated roof.

The 1938 Railway Clearing House *Handbook of Stations* reveals that Loughborough Midland was able to handle all forms of goods traffic including coal, livestock, machinery, furniture, road vehicles and general merchandise. There were, in addition, several private sidings, including connections to the nearby Coltman's Boiler Works, the Central Electricity Board and the extensive Falcon Works of the Brush Electrical Engineering Company. Another siding served the Empress Works of Messrs Herbert Morris Ltd, manufacturers of cranes, hoists, elevators and other engineering equipment.

The still-extant Falcon Works, which is situated alongside the station on the east side of the running lines, can trace its history back to the 1860s, when Henry Hughes commenced building rolling stock and lightweight steam locomotives. In 1882 the company changed its name to the Falcon Engine & Car Works Ltd, and the undertaking continued to trade under that name until 1899, when it was acquired by the Brush Electrical Engineering Company Ltd. The works produced large numbers of tramway locomotives between 1876 and 1904, while in later years Brush built main line locomotives such as the Class 31 A1A-A1As, and the familiar Class 47 Co-Cos.

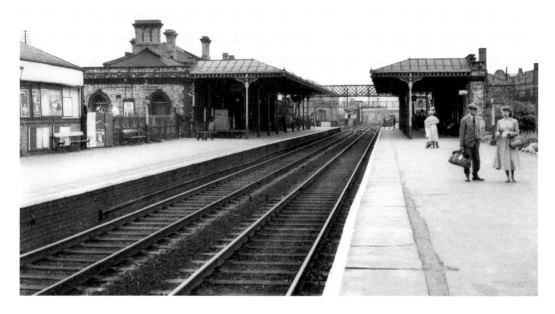

Loughborough Midland

Above: A general view of Loughborough Midland station during the British Railways period, looking north towards Sheffield around 1962. *Below*: Class 56 locomotive No. 56003 approaches Loughborough with the 10:45 Pathfinder Tours' Derby to Leicester 'Leicester Looper' railtour on 6 September 1992; this was one of a series of mini tours that ran in connection with the Leicester open day. All of the buildings in this view have been replaced by much more uniform and drab industrial units.

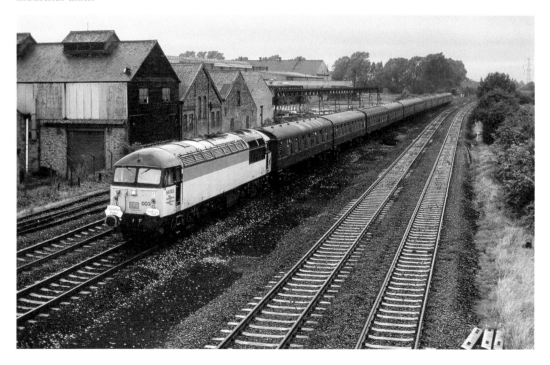

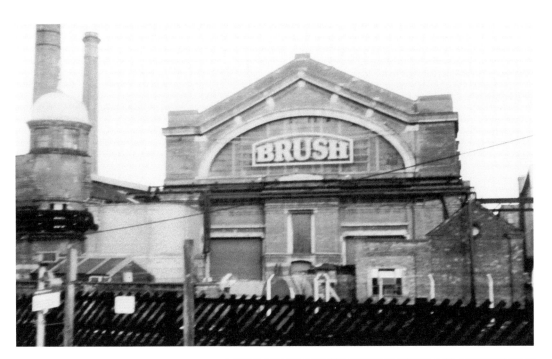

Loughborough Midland – The Brush Falcon Works

Above: The ornamental façade of the Brush Falcon Works, photographed from a train *c*. 1976. *Right*: Class 60 locomotives in various stages of construction can be seen in this view of the Brush Works at Loughborough taken on 11 August 1990. No. 60025 *Joseph Lister* is nearing completion in the foreground, with Nos 60033 *Anthony Ashley Cooper* and 600301 *Cir Mhor* at the rear. No. 60026 *William Caxton* is on the extreme right with its roof hatches open. *Bottom right*: Freshly painted DRS Class 20 locomotive No. 20305 is parked outside the Brush Works at Loughborough on 16 June 2002. This picture was taken from the embankment of the nearby Great Central Railway.

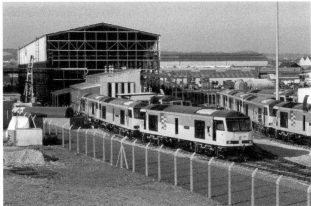

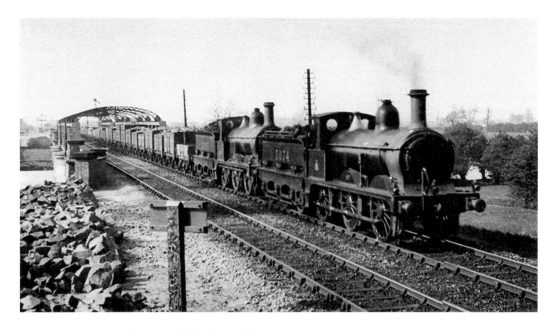

Trent Junction and East Midlands Parkway

In historical terms, Trent Junction (119¾ miles) was an important traffic centre at the convergence of several important routes, and although the station was closed with effect from 1 January 1968, the system of junctions around Trent and Sawley retains its importance as the point at which the Nottingham route joins the lines to Derby and Leicester. A new four-platform station known as East Midlands Parkway was opened on a new site to the south of the junction on 26 January 2009, this new stopping place being 118¼ miles from St Pancras. *Above*: Steam days at Trent bridge as two Midland 0-6-0 tender locomotives head southwards with a heavy coal train. *Below*: Meridian unit No. 222023 speeds through East Midlands Parkway with a St Pancras express on 11 March 2010.

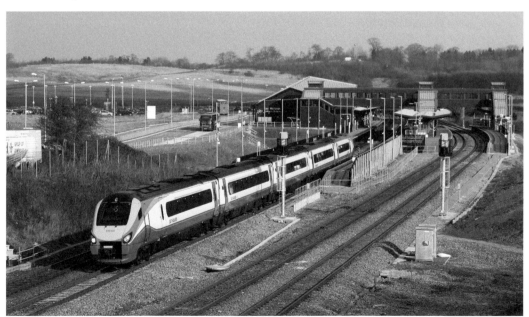

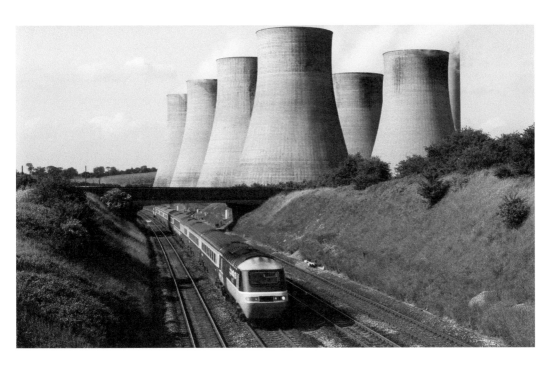

Radcliffe Power Station

East Midlands Parkway station is dominated by the adjacent Radcliffe-on-Soar power station. The upper view shows an HST set headed by power car No. 43085 *City of Bradford* passing the massive cooling towers, while working the 17:00 Derby to St Pancras service on 1 July 1985. The lower view depicts Class 158 unit No. 158806 pulling out of East Midlands Parkway with the 06:50 Sleaford to Leicester service on 11 March 2010. The base of one of the cooling towers can be discerned in the background, while the remains of the old siding connection to the power station can be seen in the foreground.

Sawley and Sawley Junction

Heading west-north-west through pleasant but unspectacular countryside, trains pass the site of Sawley station, which was opened by the Midland Counties Railway on 4 June 1839 and closed by the LMS in December 1930. The station was originally known as Breaston while, confusingly, nearby Long Eaton station became Sawley Junction in 1939. The upper photograph shows Class 170 unit No. 170108 passing Breaston while working the 11:23 Derby to St Pancras service on 23 September 2000. Breaston village can be seen in the background, together with the imposing Hopwell Hall. The lower view shows Sawley Junction station during the Midland Railway period.

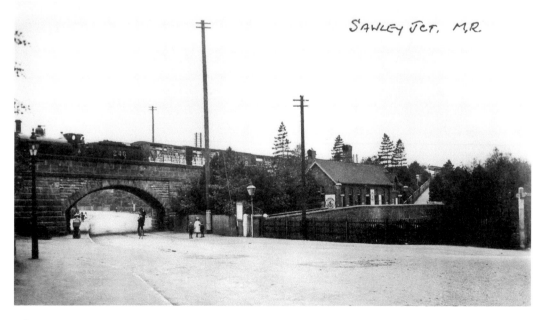

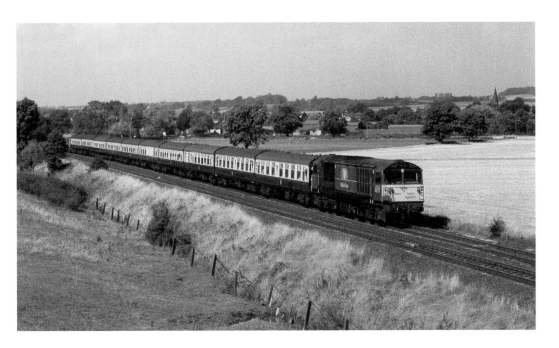

Sawley and Sawley Junction

Above: Class 58 locomotive No. 58002 *Daw Mill Colliery* passes Breaston with the Pathfinder Tours 06:26 Preston to Deepcar 'Calder Revolver' railtour on 23 September 2000. At this point in its itinerary it is running as 1Z58 (between Derby and Bradford Interchange), so the painted headcode on the front of the loco is correct, although the 'Worksop Aberdonian' wording from three years previously is not! *Below*: HST power car No. 43158 approaches a footpath crossing adjacent to the M1 Motorway at Breaston while working the diverted 06:20 Plymouth to Newcastle Virgin CrossCountry 'Armada' service on 23 September 2000.

Borrowash

The history of the intermediate stopping places between Trent, Sawley and Derby is unusually complicated, many of these stations having changed their names, or moved to new locations. Draycot (122¼ miles), for example, became Draycott & Breaston in 1939, while Borrowash (124½ miles) was opened on 4 June 1839 and resited in 1871, its name having been shortened from Borrowash & Ockbrook to Borrowash. These two old postcard views show Borrowash station in the early 1900s. Draycot was closed with effect from 14 February 1966, but Borrowash and Spondon (125¾ miles) have remained in operation as part of the national rail network.

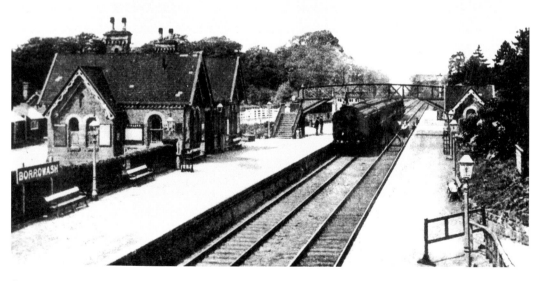

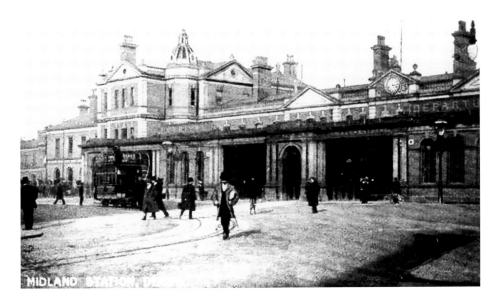

Derby Midland

Now running through the industrialised suburbs of Derby, Down workings reach Derby station (128½ miles), which was known as Derby Midland for many years in order to distinguish it from the former Great Northern station at Derby Friargate. When opened on 4 June 1839 the original station had been merely a temporary structure, but a permanent station was opened on 11 May 1840 and, according to a contemporary account, this was 'a spacious and beautiful station, surpassing any other in the kingdom, and containing the offices and engine houses for the three railways which join here, namely the North Midland, Midland Counties and Birmingham & Derby'. The station was enlarged and rebuilt on several occasions, notably at the end of the Victorian period when the main façade was reconstructed by the architect Charles Trubshaw. The upper view shows the main street level buildings, while the lower picture shows the interior of the station.

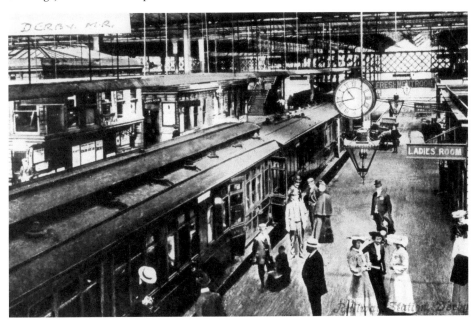

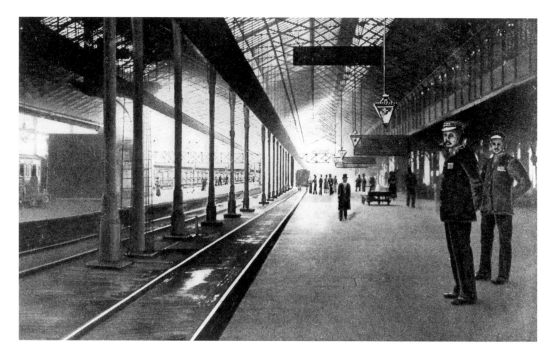

Derby Midland

The station was extensively remodelled after the Second World War, when many of the platform buildings and canopies were rebuilt in a somewhat utilitarian style, with much use of unadorned concrete. The upper picture is taken from a hand-tinted Edwardian postcard, and the lower view shows the station in BR days, after the removal of the overall roof. In its present-day form the station has seven platforms, which are numbered in sequence from 1 to 7. Platforms 1 to 6 are sub-divided into two sections by the addition of 'A' and 'B' prefixes (Platform 1, for example, is regarded as Platform 1A and 1B). Platform 7, on the east side of the station, has just one long face.

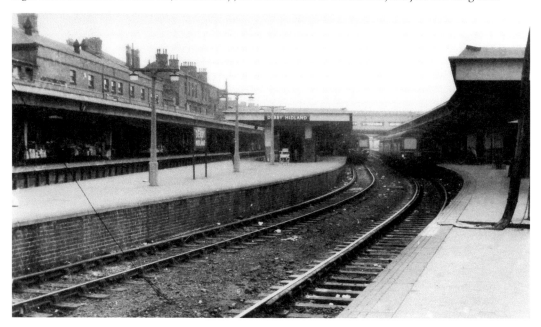

Derby

Above: Fowler Class 3F 0-6-0T locomotive No. 47660 carries out shunting duties at Derby station during the BR period; this engine was based at Derby shed for several years. *Right*: Ivatt Class 2MT locomotive No. 46454 is pictured at Derby around 1960, the above-mentioned concrete platform canopies being prominent in the background. Derby was the site of the Midland Railway's main workshops and there was, in addition, a large engine shed which, in 1950, had an allocation of 138 locomotives. The city of Derby has remained an important centre of the railway engineering industry.

Duffield

Having departed from Derby, trains proceed northwards to Duffield, some 6 miles further on. This station was opened on 6 April 1841, and it became a junction on 1 October 1867 when the Wirksworth branch was opened for the carriage of passengers. The Wirksworth line was closed in June 1947, but Duffield station has remained in use as an unstaffed halt. *Above*: The photograph, dating from around 1958, shows the branch platform and the rear of the standard Midland Railway signal box. There were, at one time, six platforms here, but these have now been replaced by a double-sided island platform. *Below*: Class 56 locomotive No. 56121 passes Duffield with a train of southbound steel empties on 8 June 1996. Duffield station can be discerned in the distance, its island platform thronged with people who are waiting to see a steam-hauled special.

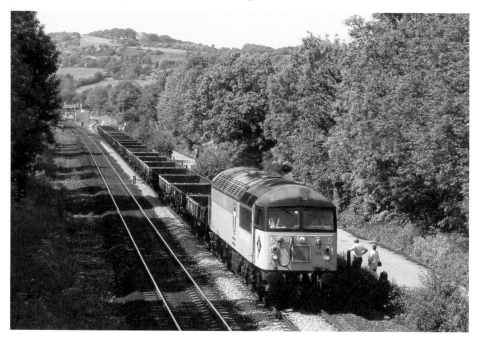

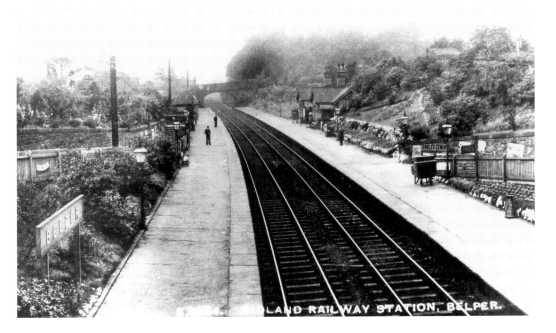

Belper

From Duffield, the route continues northwards along the Derwent Valley to Belper (136¼ miles) passing, en route, through the 855-yard Milford Tunnel. Opened on 11 May 1840, the station was rebuilt on a new site in 1878, and it remains in operation. The works in the vicinity of Belper were said to have been 'extremely expensive' during the construction of the North Midland Railway, there being 'twelve bridges in the space of one mile'. The upper photograph shows the station in the Midland Railway period around 1912, while the lower view dates from around 1962.

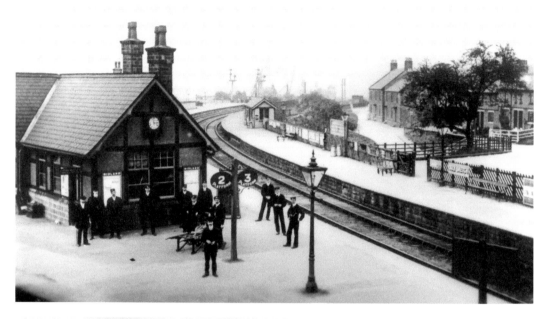

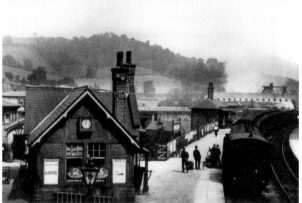

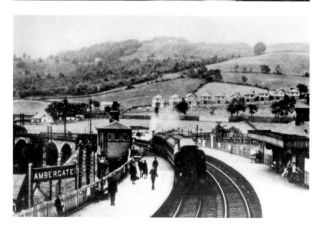

Ambergate

Having started their journey in the Home Counties and passed through the Midlands, Down trains reach an unmistakably 'Northern' landscape as they approach Ambergate (138¾ miles), where the Midland's direct route to Manchester, completed on 1 June 1863 and known as 'the Peak Forest Route', formerly diverged from the Derby to Sheffield main line. There was, at one time, an impressive triangular station here, but the northern and eastern platforms have been abandoned, and all trains now use the surviving western platform. Sheffield trains are no longer able to use the severely rationalised junction station, which is served by purely local services between Matlock, Derby and Newark. The Peak Forest line was closed beyond Matlock with effect from 6 March 1967, but part of the route was subsequently reopened as a steam-worked heritage line between Matlock and Rowsley.

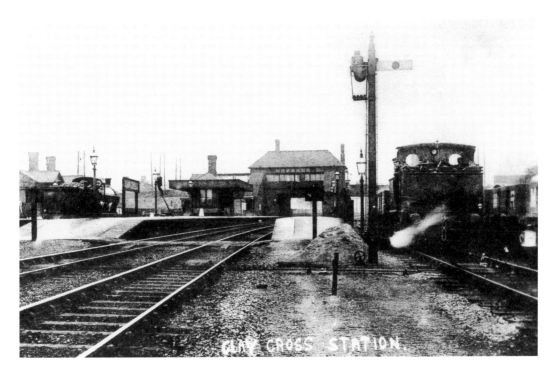

Clay Cross

Continuing northwards, trains pass a series of defunct stopping places, including Wingfield and Clay Cross, which were opened by the North Midland Railway in 1840 and closed by British Railways with effect from 2 January 1967. The upper picture shows Clay Cross station during the early years of the twentieth century, while the lower view shows Class 60 locomotive No. 60088 *Mam Tor* passing Clay Cross with the 09:58 Etruria to Lackenby steel empties on 9 April 1992. The locomotive was only a few months old at that time.

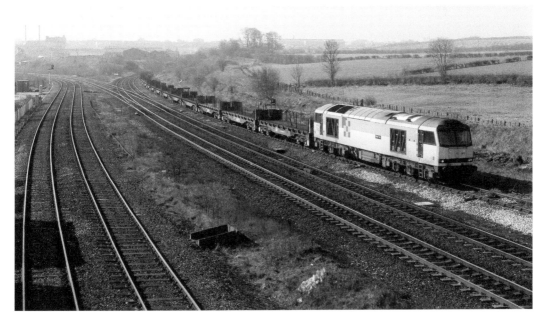

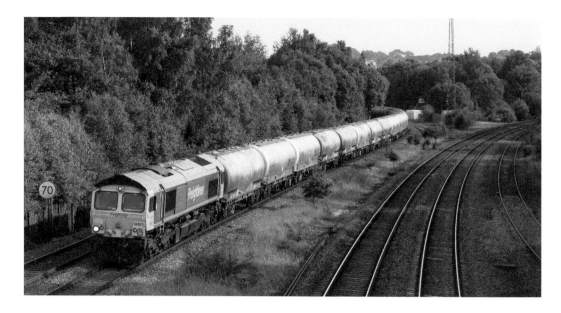

Clay Cross

Above: Class 66 locomotive No. 66621 is brought to a stand by a red signal at Clay Cross while hauling the 11:11 Theale Lafarge to Hope (Earles Sidings) empty cement train on 9 June 2018. *Below*: HST power car No. 43066, working the 17:23 Sheffield to St Pancras service, has stopped at Clay Cross on 9 April 1992, and the driver is now shouting and gesticulating at a gang of trespassing teenagers, telling them in no uncertain terms to get off the line! Obviously previous trains had noted the trespassers, allowing the HST to approach cautiously and stop – this is clearly a sight that one does not see every day!

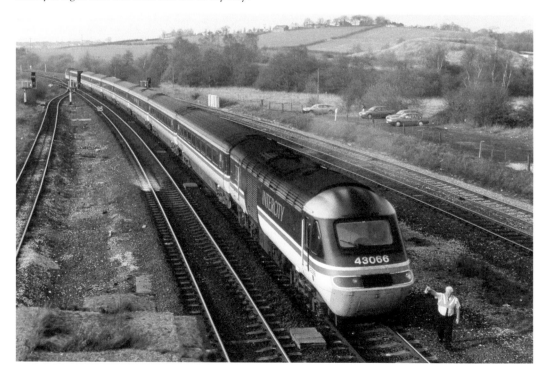

Chesterfield Midland

When opened by the North Midland Railway on 11 May 1840, Chesterfield station (146 miles) was said to have boasted a 'beautiful station house in the Elizabethan Gothic style'. The original station was rebuilt and enlarged at different times, notably in 1870 and again in 1963. A further rebuilding took place in the 1990s – although it is interesting to note that parts of the characteristic Midland canopies have been retained. Three platforms are available, Platforms 1 and 2 being the main platforms for Up and Down traffic, while Platform 3, on the west side of the station, is signalled for bi-directional working. The platforms are linked by an underline subway, and the main station buildings are on the Down side. The photographs show the platform and canopies during the early years of the twentieth century.

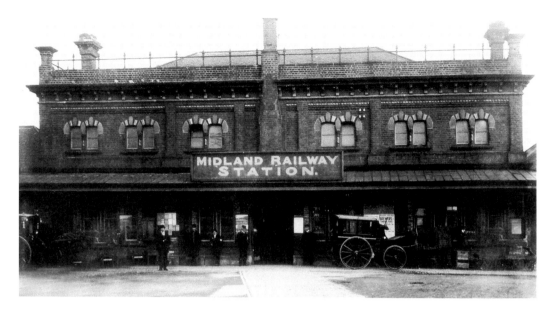

Chesterfield Midland

The upper view provides a detailed look at the main station building, which replaced the earlier Elizabethan-style structure, and has itself been replaced by a modern building. The lower view shows the platforms, probably during the 1950s. The 1938 Railway Clearing House *Handbook of Stations* reveals that Chesterfield was able to handle a full range of goods traffic, including coal, livestock, furniture, vehicles, horse boxes and general merchandise. There were, in addition, a large number of private sidings serving various local industries, while other facilities in the Chesterfield area included Hasland Motive Power Depot, which was sited to the south of the station on the Up side of the running lines. In 1959 Hasland shed had an allocation of forty-nine locomotives, including seventeen 0-6-0 Class 3F and Class 4F freight locomotives and a dozen Beyer-Garrett 2-6-0 + 0-6-2Ts.

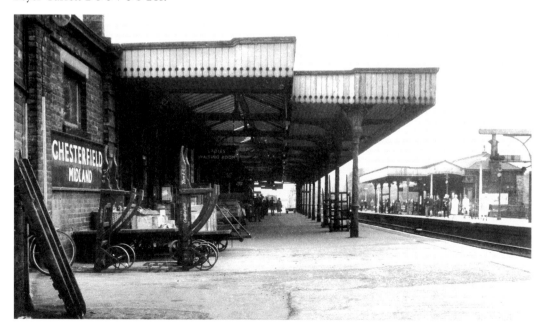

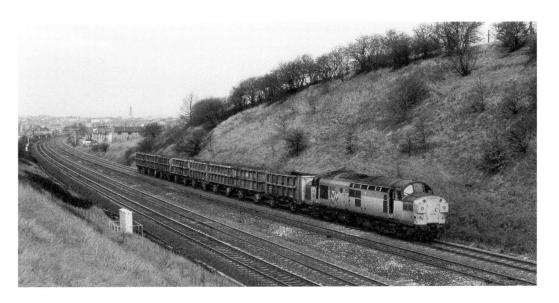

Chesterfield Midland

Above: With the famous twisted spire of Chesterfield church just visible in the distance, Class 37 locomotive passes Hasland with a short train of scrap-carrying wagons on 27 February 1992. The SSA scrap wagons were built between 1978 and 1984, and they were initially coded POA.

Below: The unmistakable crooked spire of Chesterfield church immediately identifies this location. On a very dull 18 February 1995, Research & Development unit No. 901002 *Lab 19 Iris 2* (composed of vehicles 977693 and 977694) heads north, passing a local second-hand car dealer's yard. This unit was converted from Class 101 vehicles Nos 50222 and 50338 in 1991. The rather drab grey livery was their first colour scheme, but this sombre livery was later followed by the much more colourful Serco red and grey, Railtrack blue and lime green, and ultimately by Network Rail all-over yellow. The unit entered preservation in 2008, ending up in the much more conventional green livery.

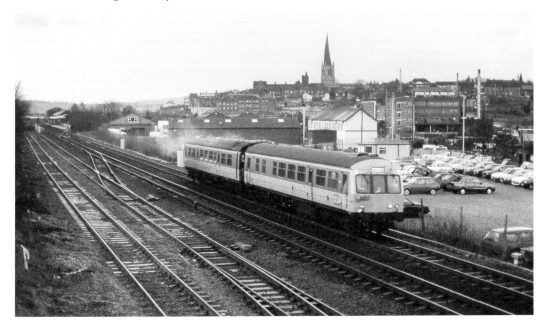

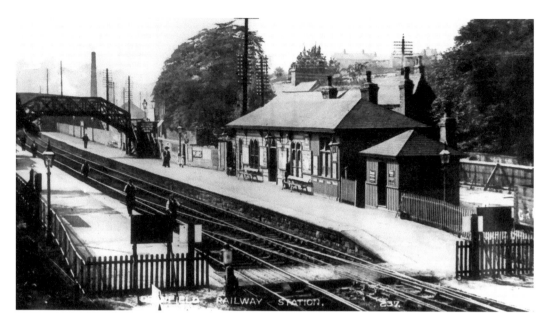

Dronfield

Still heading more or less due northwards, Down trains reach the Sheffield & Chesterfield line which, as we have seen, was opened in 1870 in order to provide an improved route for London to Sheffield traffic. Sheepbridge, the first intermediate station, was opened on 1 August 1870 and closed with effect from 2 January 1967, while neighbouring Unstone was opened on 1 February 1870 and closed with effect from 29 October 1963 (apart from excursion traffic). Beyond, the route continues to Dronfield, which was closed at the same time as Unstone but reopened on 5 January 1981. The main station building, on the Up side, was a timber-framed structure with a hipped roof, but the station is now equipped with substantial stone waiting shelters on both platforms.

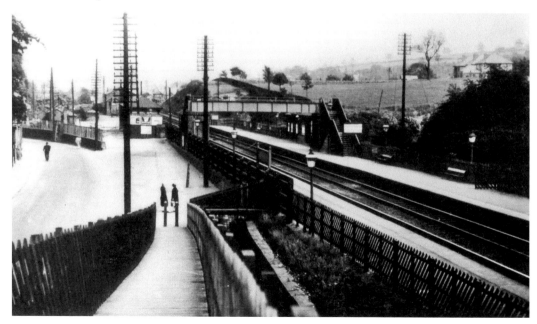

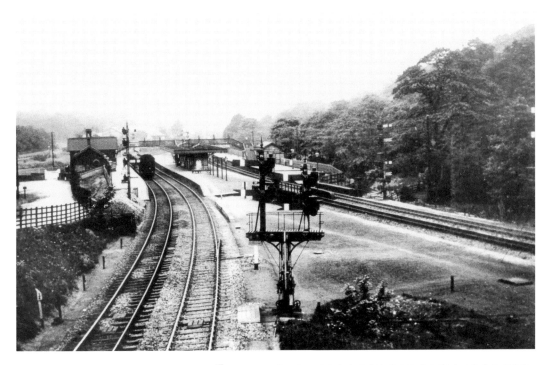

Dore & Totley

Opened in 1872, Dore & Totley, the next stopping place, became a junction in 1894 when the Hope Valley route to Manchester was brought into use. In its heyday this Sheffield suburban station had six platforms, but it is now an unstaffed halt with just one platform and a simple brick-built waiting shelter, although the former station building has survived in private ownership as the Rajdhani Indian Restaurant. The upper pictures are Edwardian postcard views from around 1909, while the lower photograph shows the station in BR days before the withdrawal of staff and reduction in facilities. The station is at the present time used by approximately 179,000 passengers per annum.

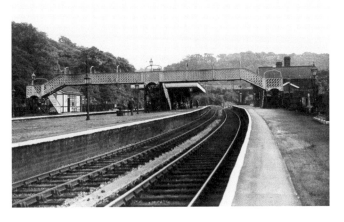

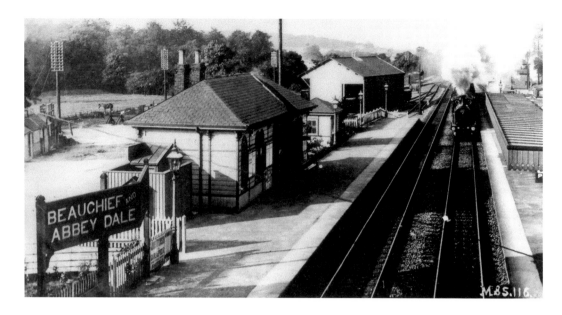

Beauchief & Abbeydale

Nearing their destination, Sheffield-bound services pass the site of Beauchief station, which was opened with the line on 1 February 1870 and closed with effect from 2 January 1961. The station was originally known as Abbey Houses, although it was later dubbed Beauchief & Abbey Dale – Abbeydale being an industrial settlement on the outskirts of Sheffield. When first opened, the station had two platforms, but two additional platforms were constructed when the line was widened in 1901–03. The upper photograph was taken from the lattice girder footbridge, and it shows the main station building, which was a timber-framed structure with a hipped roof. The lower view shows the platforms and station buildings, the footbridge and station master's house being visible to the left of the picture.

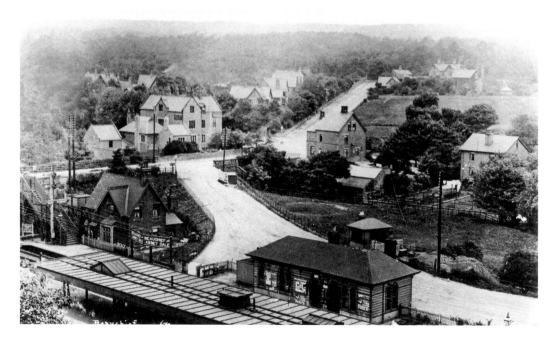

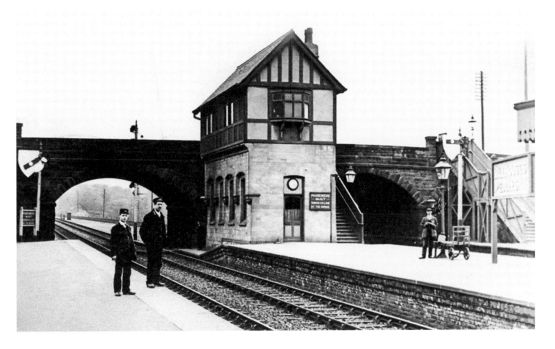

Millhouses & Eccleshall

Millhouses & Eccleshall station, the ante-penultimate stopping place en route to Sheffield, was opened in 1870 and enlarged in 1901–03 when the line was quadrupled. The station, which was closed with effect from 10 June 1968, was also the site of a motive power depot – this facility being sited to the north of the station on the Down side. In 1950 it had an allocation of forty-one locomotives, including nineteen Jubilee and Black Five Class 4-6-0s. The shed was coded 19B in 1948, becoming 41C in 1958. From Millhouses, the route continues north-west, passing the site of another closed stopping place at Heeley, which was in use from 1 February 1870 until 10 June 1968. Here, the railway leaves the valley of the River Sheaf, which has provided a convenient route for the past 5 miles.

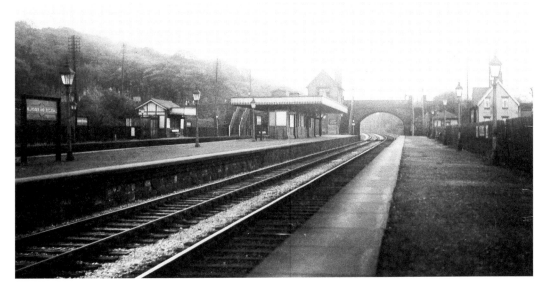

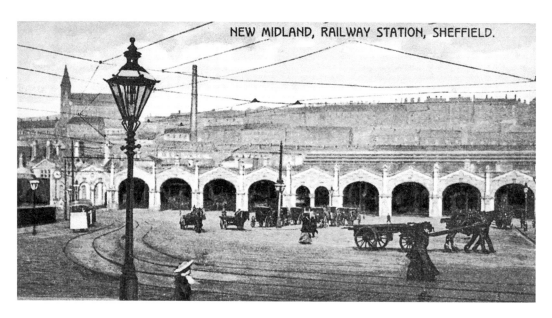

Sheffield Midland

Having passed through the short tunnels at the southern end of the station complex, trains finally draw to a stand at Sheffield Midland station, some 158¼ miles from St Pancras via the Derby route. The railway reached Sheffield on 1 November 1838, the original station being at Sheffield Wicker, which was replaced by the present station on 1 February 1870. The station was enlarged and rebuilt in 1904–5, the architect being Charles Trubshaw. Further alterations were put into effect in the 1950s and in 2002, but the station has nevertheless retained much of its Victorian character. It now has nine platforms, most of these being double platforms with A and B sections; the platforms are linked to the main station building by a large footbridge. The photographs show the interior and exterior of the station during the early 1900s, the stone façade being particularly striking.

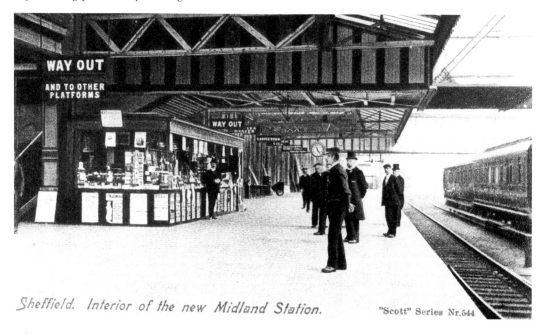

Sheffield. Interior of the new Midland Station. "Scott" Series Nr.644